ANCIENT EGYPT

An Adult Colouring Book

Hilary & John Robert Travis

ANCIENT EGYPT: An Adult Colouring book

Hilary & John Robert Travis; First published 2016.

ISBN - 13: 978 – 153493723

ISBN - 10: 1539493725

Copyright © 2016 Hilary & John Robert Travis

All rights reserved.

No part of this publication may be reproduced, stored in a retrieval system or transmitted in any form or by any means, mechanical, electronic, photo-copying, recording or otherwise without the prior written permission of the authors.

CONTENTS

INTRODUCTION	5
THE OLD KINGDOM (THE PYRAMID PERIOD)	6
ART	14
LIFE	30
RELIGION	46
BOOK OF THE DEAD	66
FAMOUS PEOPLE OF THE NEW KINGDOM	74

INTRODUCTION

The most important thing about this book is that it is NOT a history book. It has been produced purely for the purposes of stress-free relaxation, providing interesting pages for creative colouring in by adults (and I include those of us who just pretend to be "adults" during office hours). It will not teach you everything you need to know about Ancient Egypt. There are plenty of history books already out there for that.

This book is however dedicated to the real artists, sculptors and architects of Ancient Egypt. Many of the pictures provided here for you to colour-in drew their inspiration from the surviving sculptures and wall paintings decorating its temples; pyramids and the tombs of the ruling families and other wealthy members of society.

So, while you colour your way through these pages, we will also look pictorially at aspects of Egyptian life and culture: including religion and mythology; fashions; food; entertainment; art and architecture.

THE OLD AND MIDDLE KINGDOMS (THE PYRAMID PERIOD)

This period of Egyptian art history was dominated by the development of the pyramid. Between 118 and 138 pyramids have been located in Egypt, the majority of which being constructed for the pharaohs and their consorts. The earliest known pyramids were constructed during the third dynasty at Saqqara northwest of Memphis. The earliest of these were constructed for the Pharaoh Djoser (Zoser) 2630 BC - 2611 BC. This pyramid and its surrounding complex were designed by the architect Imhotep and are considered to be the oldest monumental structures to have been constructed in stone. The most famous pyramids were constructed during the fourth and fifth dynasties at Giza, on the outskirts of Cairo. The Giza complex comprises of three independent complexes. The largest and earliest complex includes the Great Pyramid, which was constructed by the Pharaoh Khufu (Cheops), and comprises of the main pyramid, a mortuary temple, three smaller queen's pyramids and five boat pits, along with a now destroyed worker's village. The other two complexes are the pyramid complex of Khafre (Chefren) and the pyramid complex of Menkaure, which dates to the fifth dynasty.

> The earliest dateable work of Egyptian art is the Palette of Narmer. Narmer was the first king of the First Dynasty, about 3000 BC (5,000 years ago). This palette shows Narmer's victories. It is carved with 'reliefs' which means that the artist has carved away the slate background to make the pictures stand out.

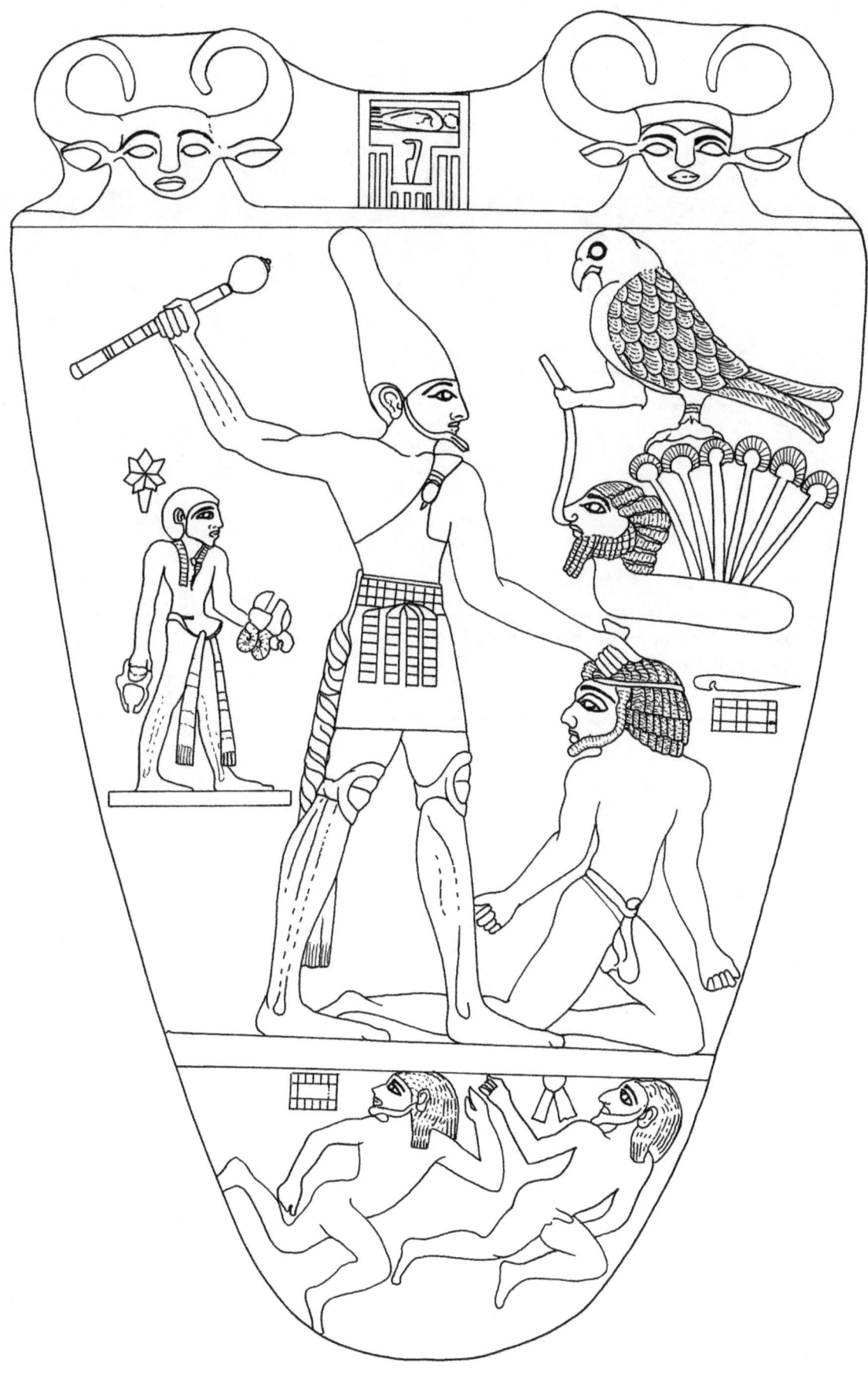

King Djoser (Zoser) running for the Hebsed celebration (relief from the underground galleries).

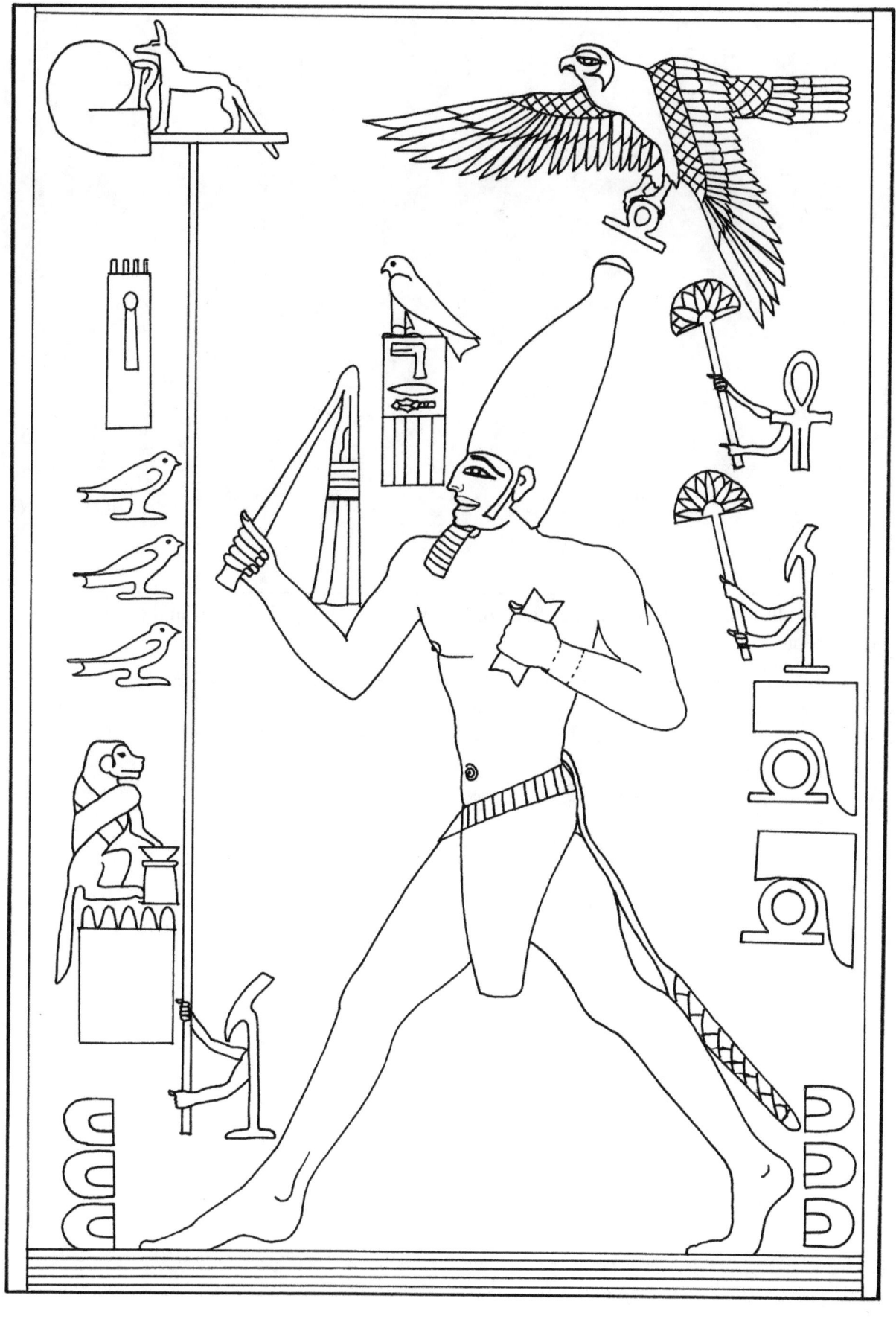

The Step Pyramid of Djoser with a statue of the architect Imotep (Imhotep) in the foreground.

ANCIENT EGYPT

11

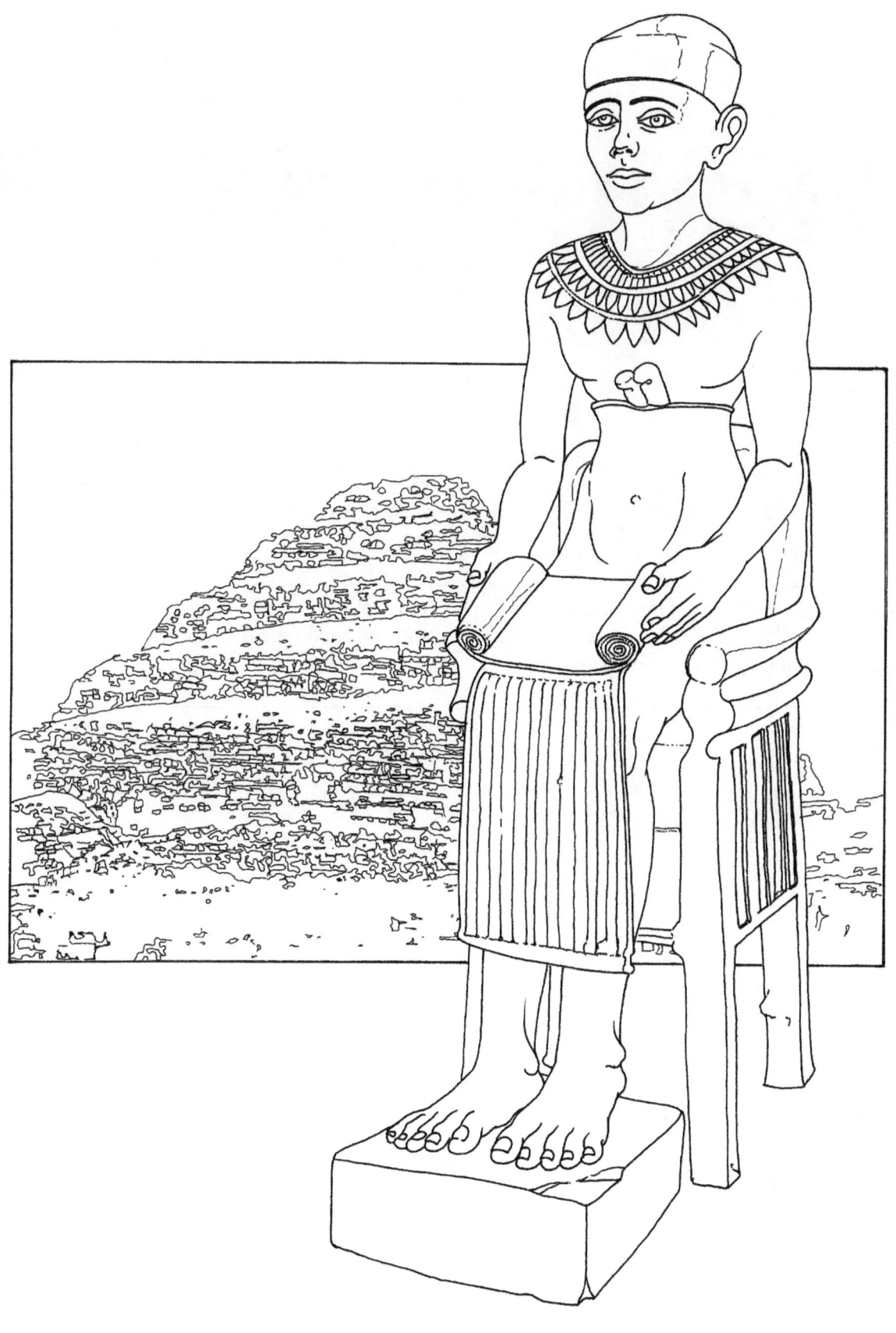

Workmen building the Great Pyramid. The workers would have lived in a small artisan's village close by. Recent evidence from archaeological excavations suggests that most of these workers were paid artisans, rather than slave labourers.

ANCIENT EGYPT

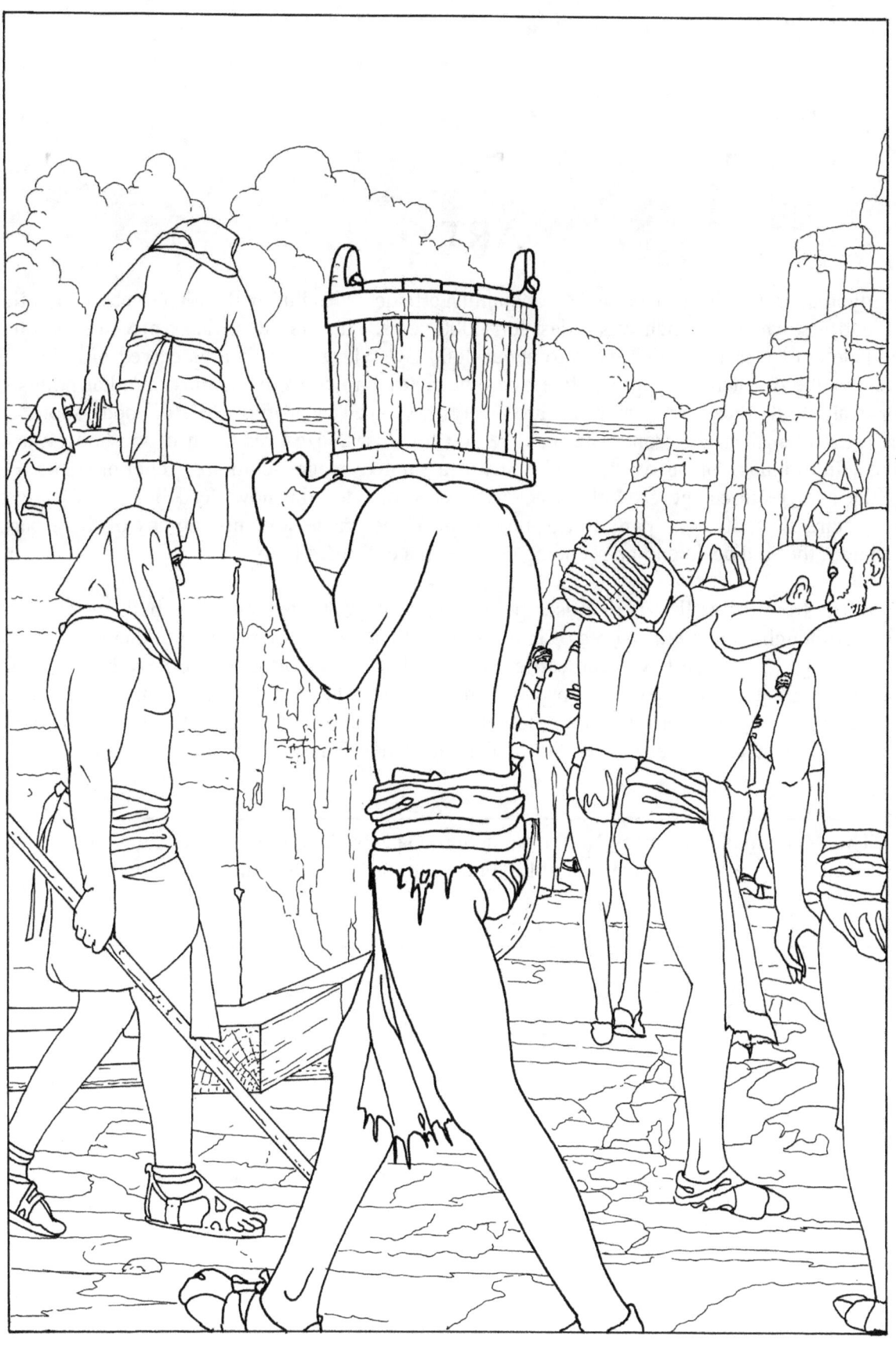

ART

Initially Egyptian art was influenced by Mesopotamian artistic styles but by the First dynasty Egyptian art had found its own style which was to last for 3,000 years. The first identifiable piece of Egyptian art is the Palette of Narmer, which dates to about 3000 BC. The slate palette is carved in relief and already shows the distinctive Egyptian style, with the figure shown from the most familiar points of view, for example the head, arms and legs are always portrayed in profile while the body shoulders and eyes are shown from the front. The main reason for this stylized rendition of the body was to enable the soul to inhabit the artwork, whether it was a painted image, sculptured relief or statue. For this end the soul required the artwork to act as a substitute for the now dead body. This would therefore require all of its body parts to be present and if the image was missing any of these parts, such as an arm, the soul could end up spending eternity in a deformed body.

Egyptian artists from the earliest period used bold, bright colours to decorate their buildings, statues, pottery etc. Although there are instances of indifferent and bad art, as in any period, the work carried out for the ruling class would have been carried out by what was then thought to have been the best artist-craftsmen of their time. These artisans would have viewed their art differently than we do today. For example, art during this period was not done to hang in a museum or to gratify the artist's inner mental and emotion state, but was created for the benefit of their Gods, kings, queens and the dead.

> The Meidum Geese from Nefermaat's mastaba. Brightly coloured pictures of Geese were painted on the walls of Egyptian tombs of the Old Kingdom more than 4,500 years ago.

ANCIENT EGYPT

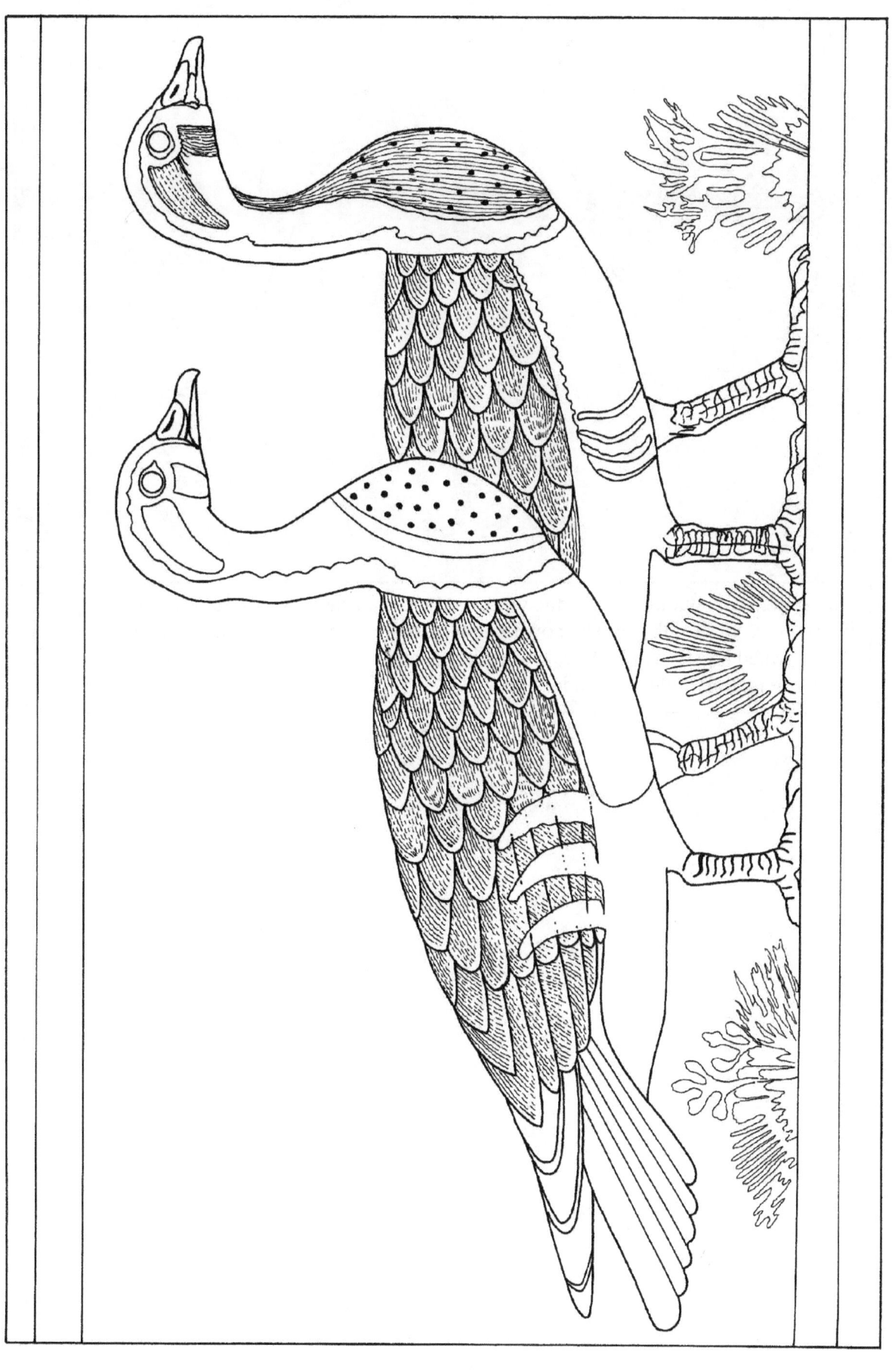

An Egyptian art studio. Most of the work was accomplished by skilled artisans living in worker's villages. The now famous bust of Queen Nefertiti was found in an excavated artist's studio. Here one sculptor can be seen working on a cat effigy, as representation of the cat goddess Baset.

ANCIENT EGYPT 17

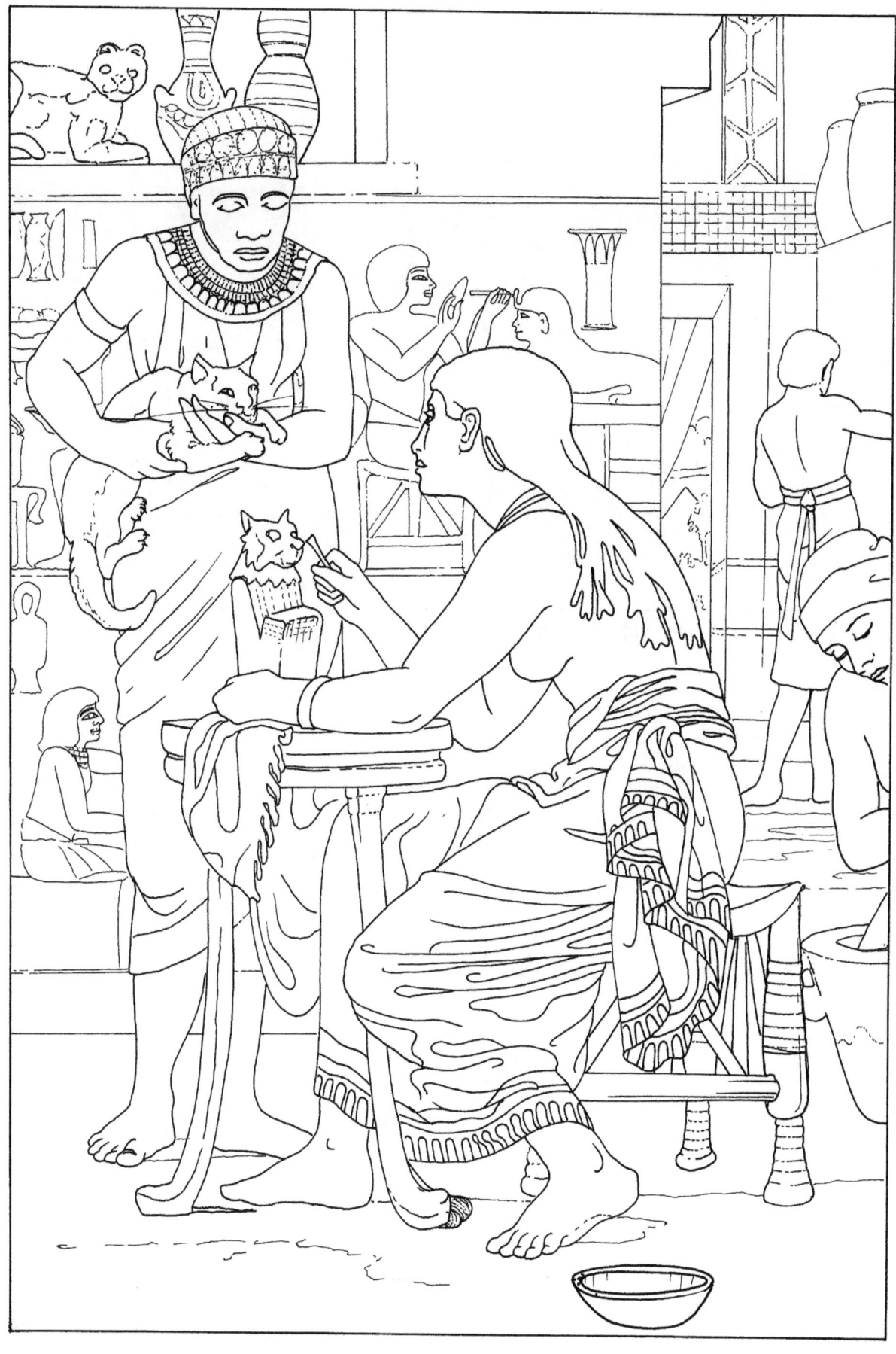

Hieroglyphic symbols with their equivalent phonetic sound in the modern alphabet.

ANCIENT EGYPT

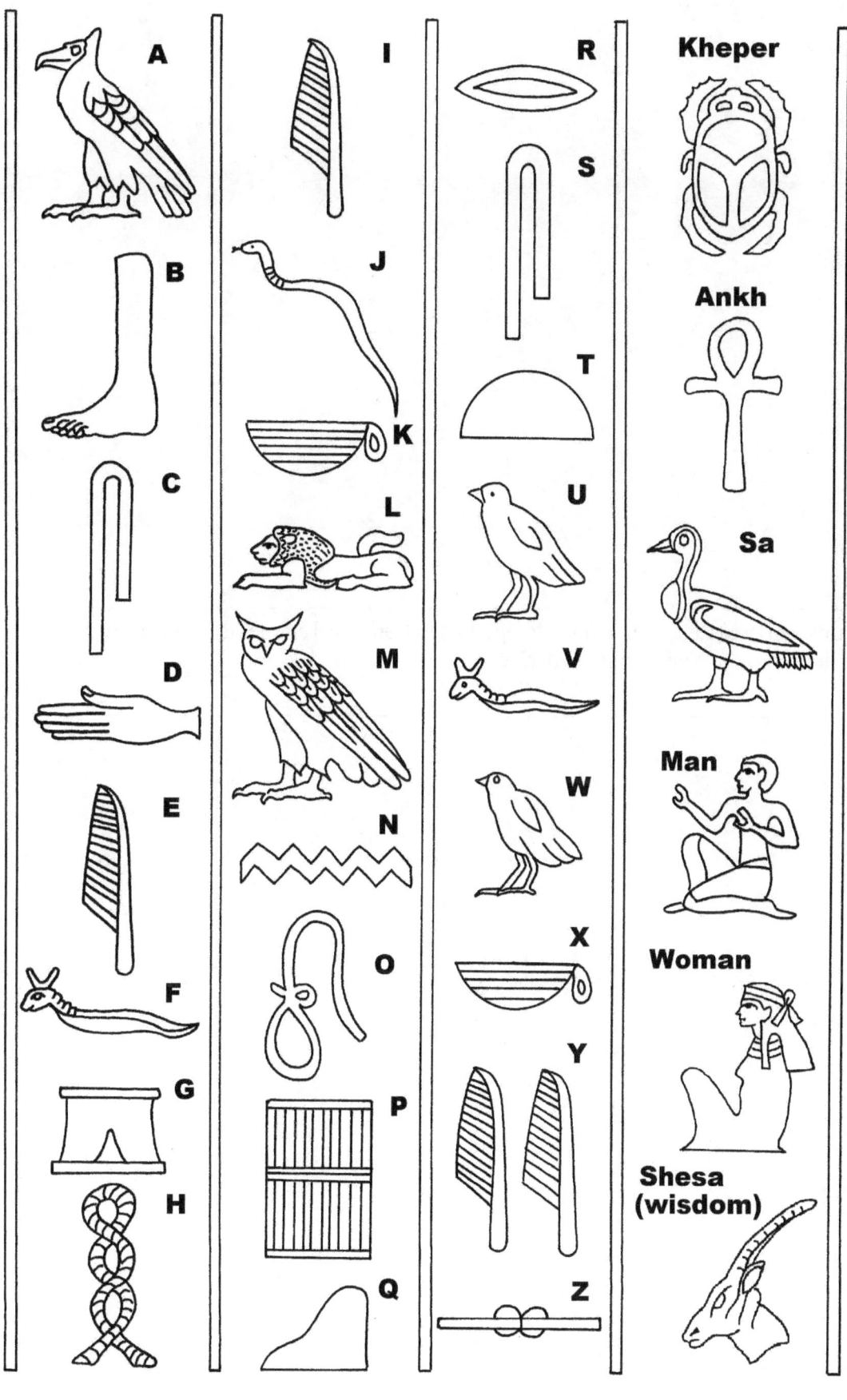

Birds and papyrus, seen in a landscape fresco from the Temple of Amarna, Egypt, dating from the New Kingdom period.

ANCIENT EGYPT

Ra pendant from the tomb of Tutankhamen.

ANCIENT EGYPT

Vulture pendant (representing Nekhbet, the vulture goddess of Upper Egypt), from the tomb of Tutankhamen (c. 1370-52 BC), dating to the 18th Dynasty (New Kingdom). The necklace, made from solid gold, encrusted with blue lapis lazuli and red carnelian, was found below the innermost layers of the mummy's wrappings.

Pendant showing the symbols of Upper and Lower Egypt, and the symbol of Horus.

ANCIENT EGYPT

Queen Nefetari (first of the Great Royal Wives of Ramesses the Great (Ramesses II), being led by the Goddess Isis. Nefertari lived c. 1371 to 1256 BC. Her full name was Nefertari Merymut, "Nefertari" meaning "Beautiful Companion" and "Merymut" meaning "Beloved of [the goddess] Mut".

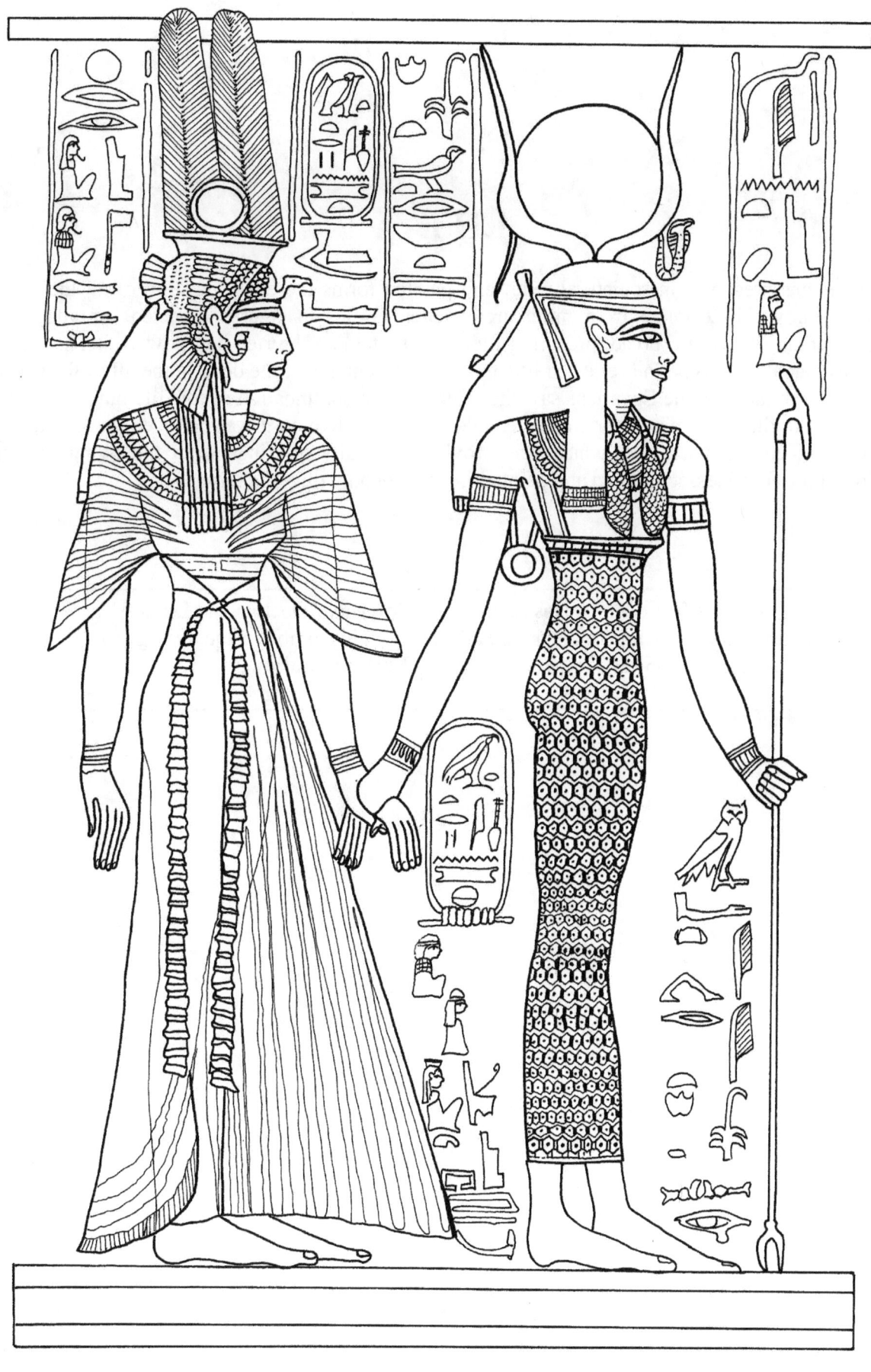

LIFE

Egyptian art has preserved in sculptural relief and painted forms the every day life of all the social layers of society. These range from miniature wooden armies to figures depicted everyday life, including grinding wheat for bread, preparing food or entertaining the rich and powerful. The reason for this was that art in this period reflected life and the requirements of the dead in the afterlife. This in part is due to the fact that the Egyptians saw the after life as a continuation of this life but without the nasty things like illness, famine, war etc. To enable the soul to live on it was believed that it required food, clothing, entertainment etc. which was provided by daily offerings from the living and the animation of the figurines, sculptured and painted images found within the tombs.

> One of history's first doctors, Hesire, the "Chief of Tooth-Doctors and Doctors" at the court of the Old Kingdom pharaoh, Djoser; from his tomb at Saqqara, Egypt, Third Dynasty, c. 2650 BC (in wood, Egyptian Museum, Cairo).

ANCIENT EGYPT

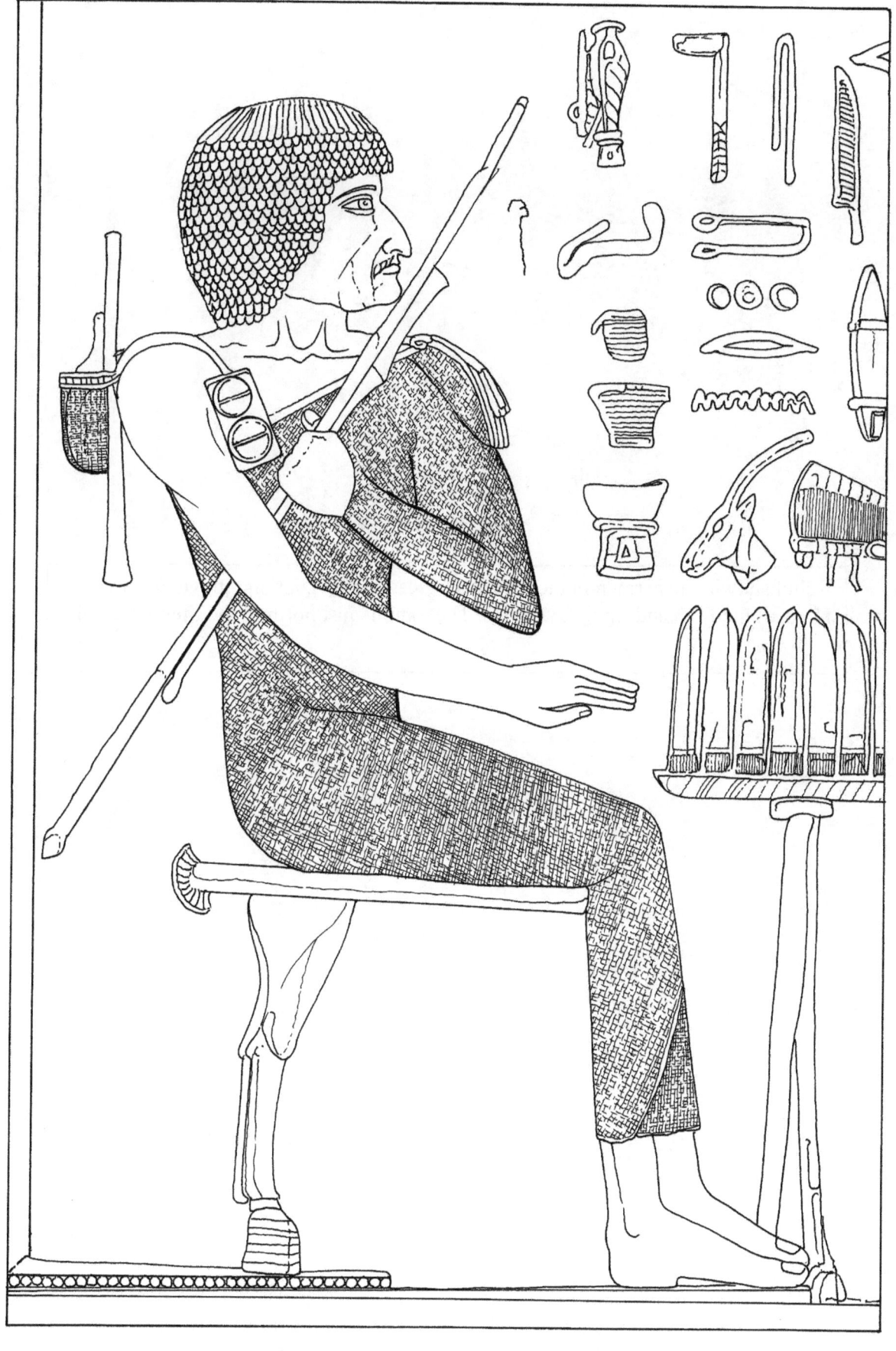

Relief showing fishermen in the mastaba of Kagemni, vizier and judge under three kings of the Fifth and Sixth Dynasties. The tomb is just north of the Step Pyramid.

ANCIENT EGYPT

33

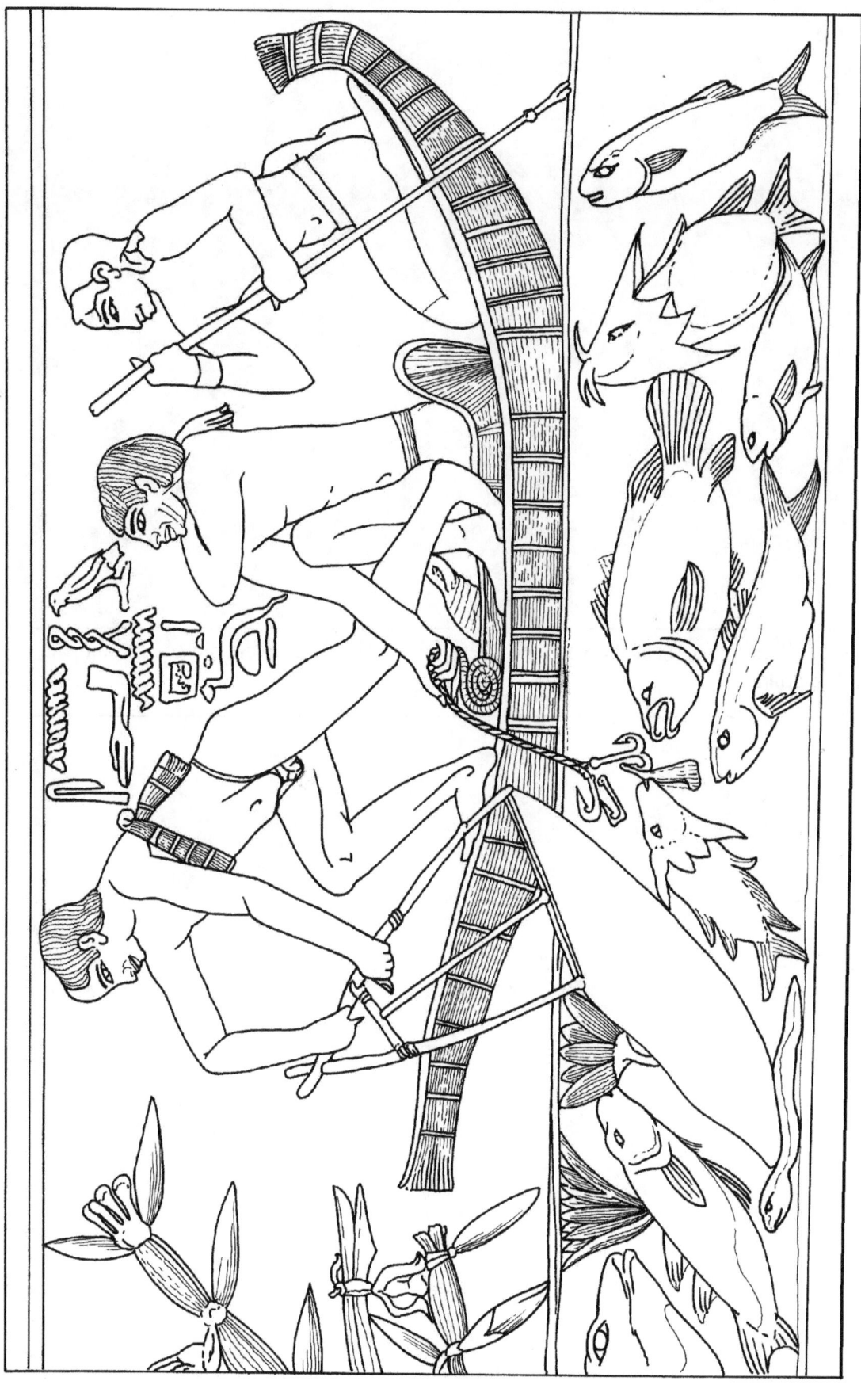

A still life with fish showing the great variety of food available to the ancient Egyptians.

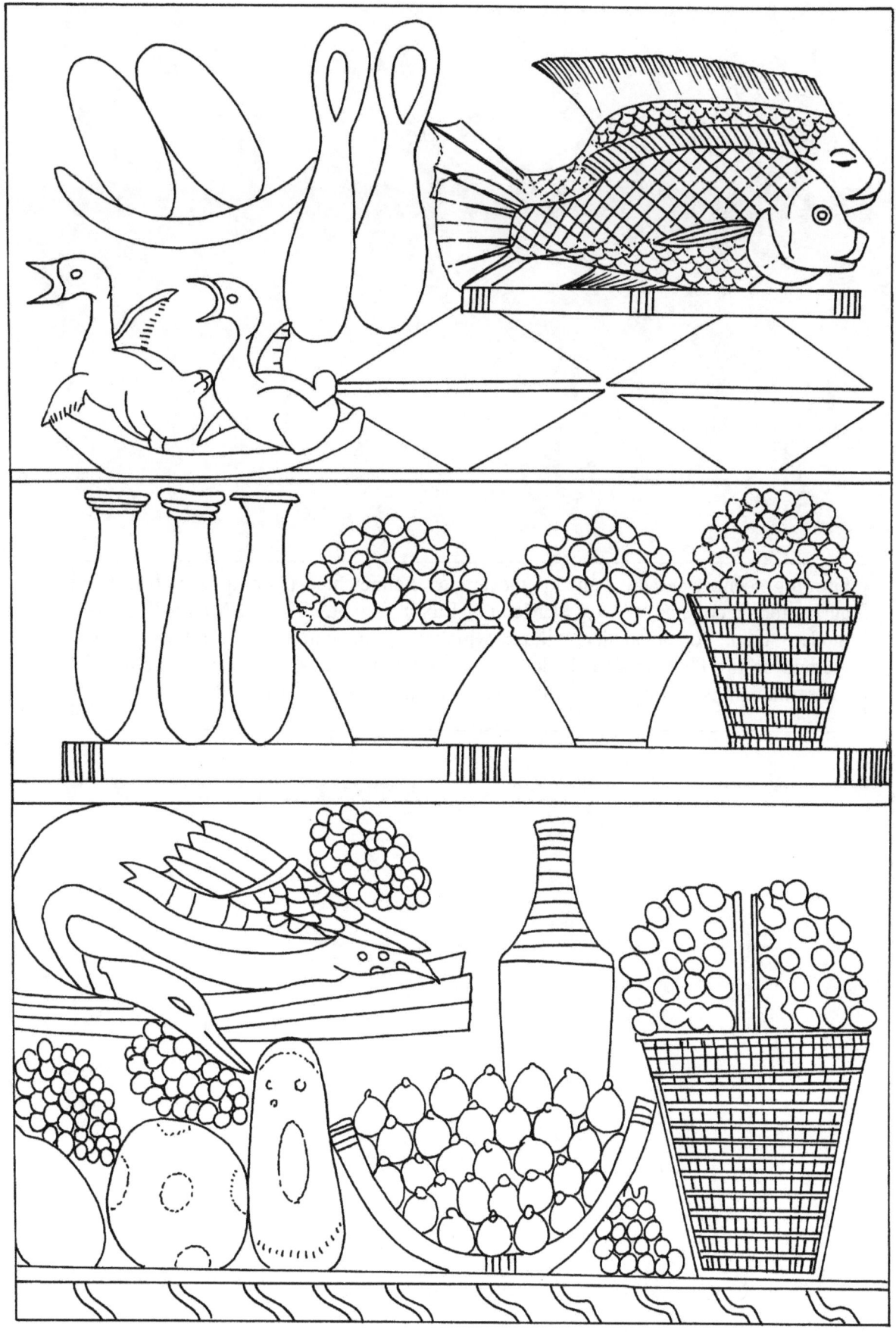

Farming scene from the tomb of the artisan Sennejen: a painting depicting the agricultural economy at Dier el Medina, Luxor, Egypt. "Dier el Medina" is the modern name for an ancient village which was the home to the artisans who worked on the Pharoah's tombs in the Valley of the Kings. The original name of the settlement was "Set Maat" which translates as "The place of Truth".

ANCIENT EGYPT

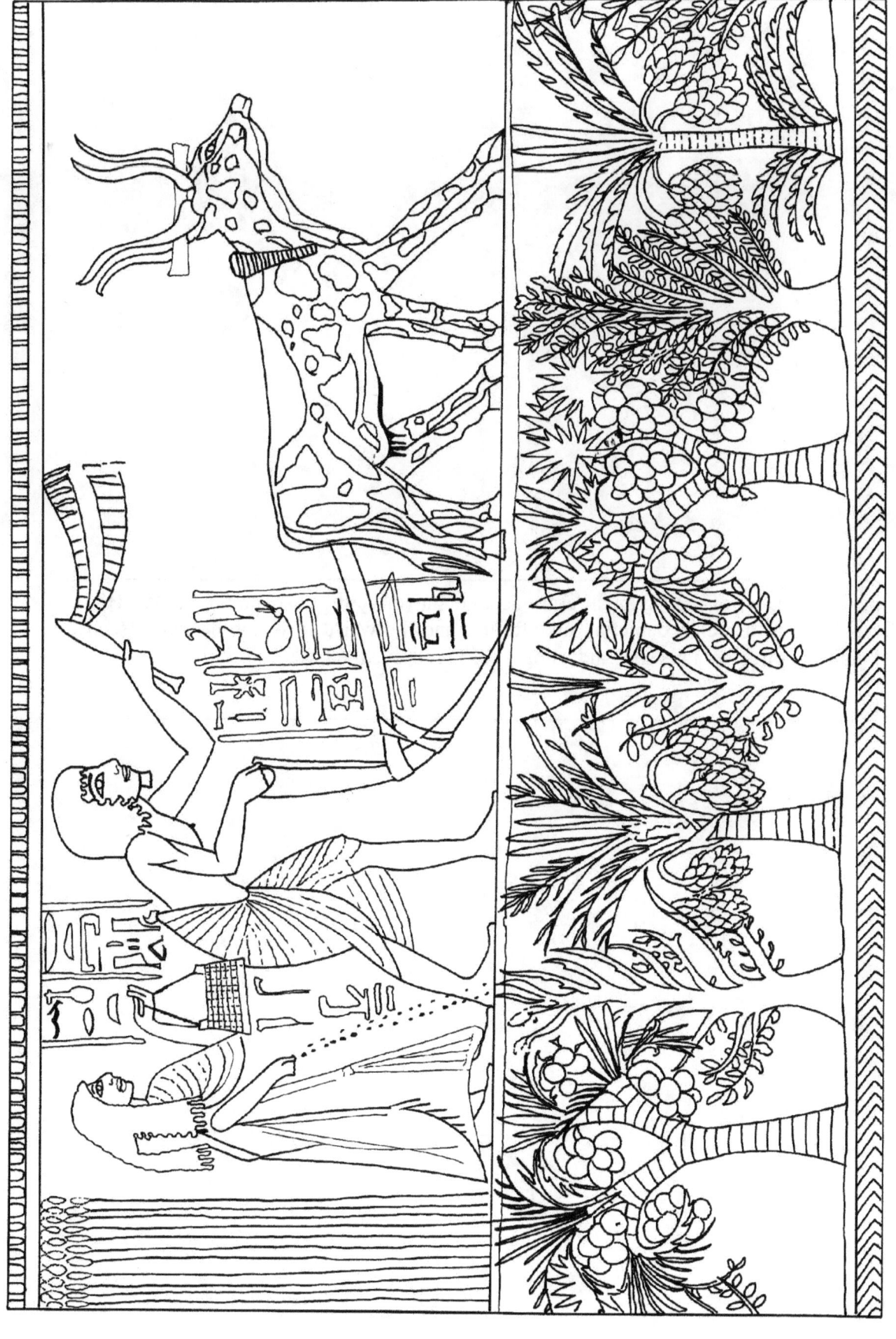

Tomb-chapel of the Egyptian grain accountant (or scribe), Nebamun, c.1350 BC, painted with scenes depicting his afterlife and the world in which he lived (seen hunting birds with his son, and using a cat to retrieve the birds).

ANCIENT EGYPT

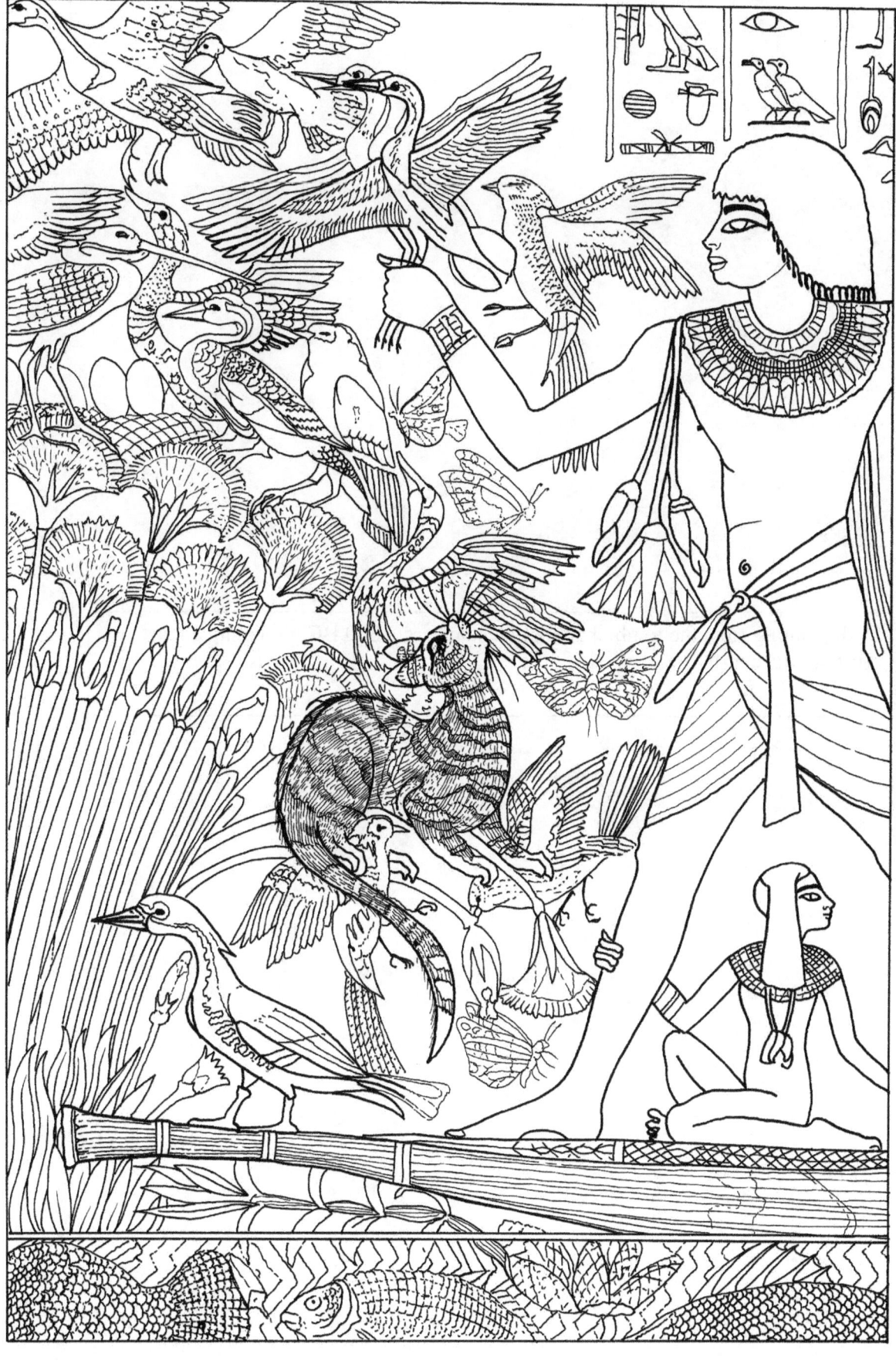

Wall painting from the tomb-chapel of Nebamun, c. 1350 BC, depicting a feast (British Museum).

ANCIENT EGYPT

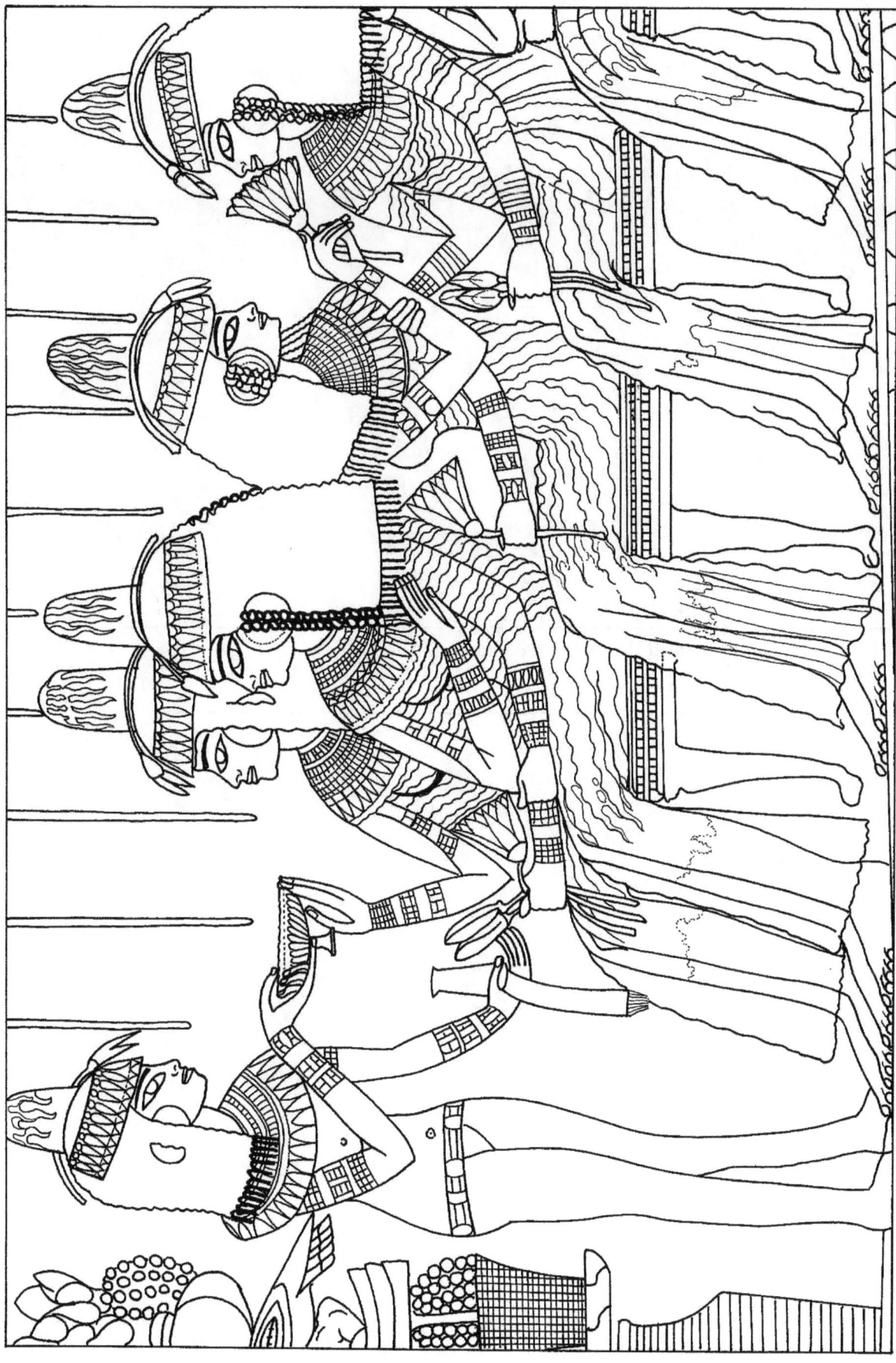

Musicians and dancers at the feast for Nebamun, c. 1350 BC.

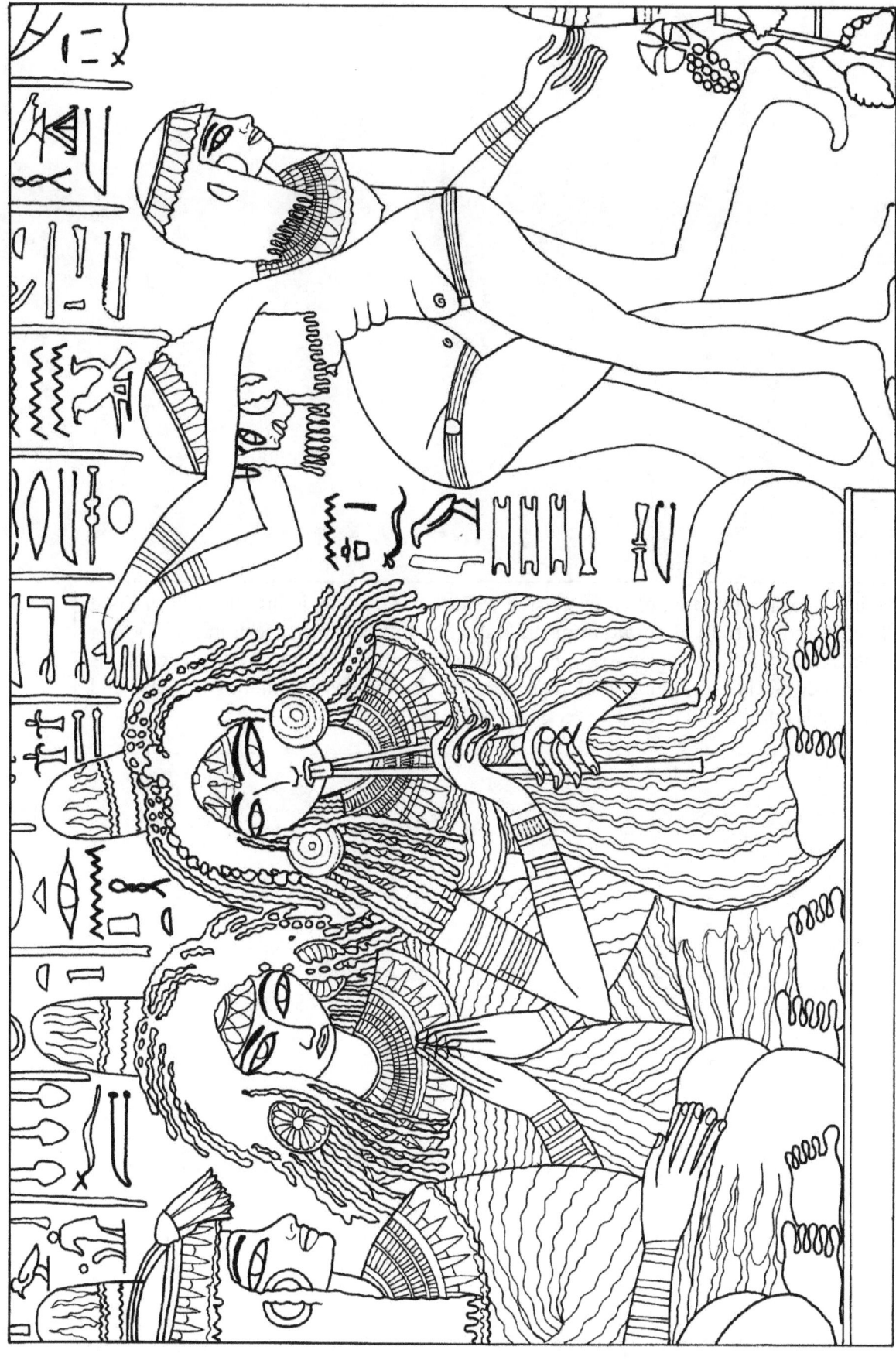

Just one small section of an expansive water landscape depicting the Nile in flood at Memphis, from a mosaic from the Italian city of Palestrina (originally flooring an apse of Sulla's sanctuary at *Fortuna Primigenia*, 1st century BC). It contains detailed scenes depicting Ptolemaic Greeks, Ethiopians in hunting scenes, and animals common to the Nile river.

ANCIENT EGYPT 45

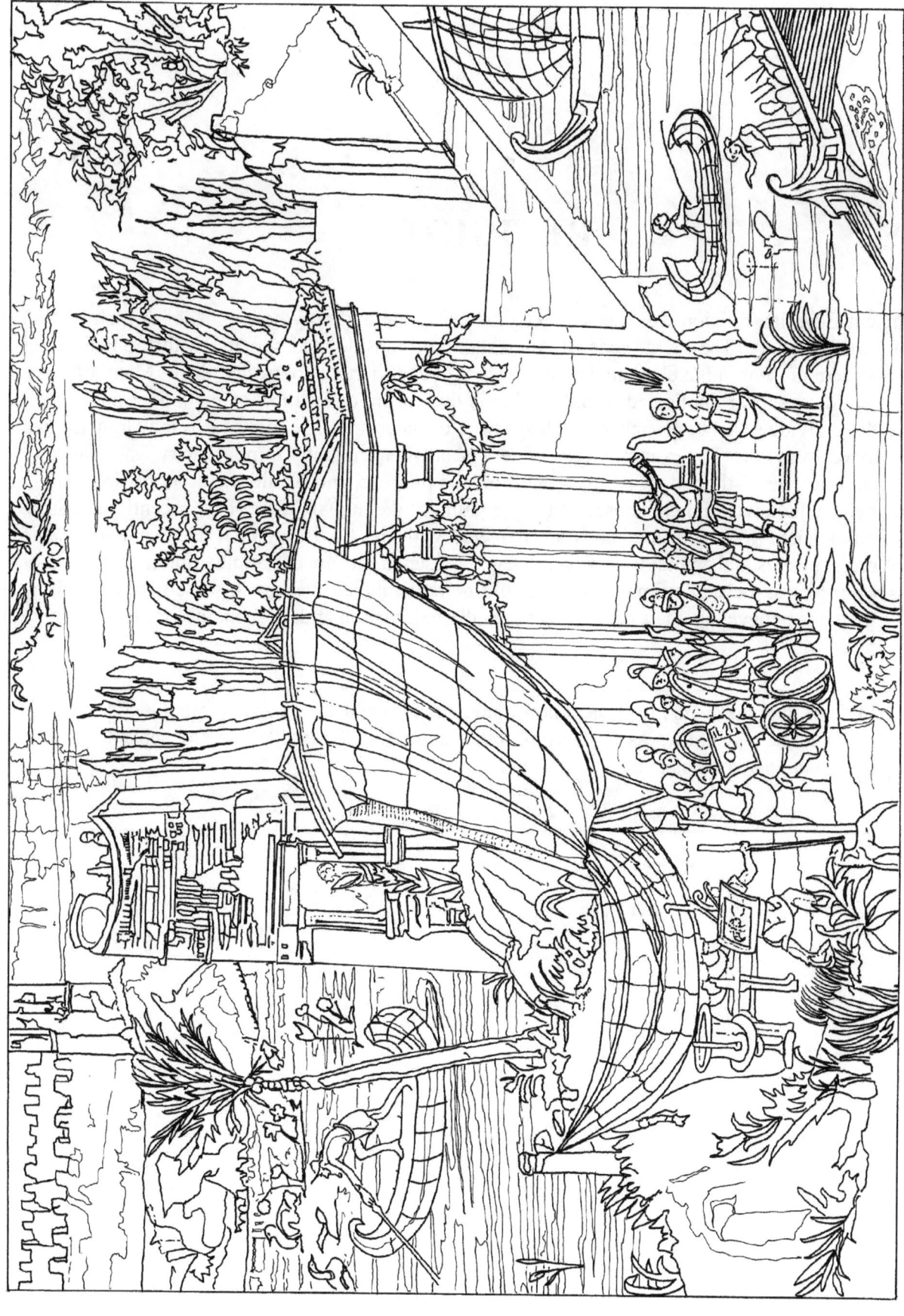

RELIGION

The Ancient Egyptian religion was a complex system of ritual and polytheistic beliefs which was an integral part of society. The many gods of Ancient Egypt consolidated society, with the belief that these gods were present in the elemental forces of nature and thereby controlled them. Many of these gods and goddess appear duplicated to us but this is due to the unification of the Upper and Lower Nile and the individual deities associated with specific towns or areas. In some cases they transformed and developed over time. For example, the goddess Maat was originally a moon deity who was later transformed into one of the judges of the dead. For this purpose, she would pluck an ostrich feather from her head, which would then be used in the weighing of the human heart of the recently deceased. Many of the ancient gods and goddesses are depicted with the bodies of men and women and the heads of birds, beetles and animals. However, these representations are a complex union of the god or goddess with their associated animals and it should be remembered that not for one moment did the ancient Egyptians believe that their deities were actually half human and half animal (or bird).

> Stele of the musician Amon Djedkhonsouiouefankh playing the harp before the god Ra-Harakte, also known as the Harp player worshipping the god Horus, the ancient Egyptian god of the sun.

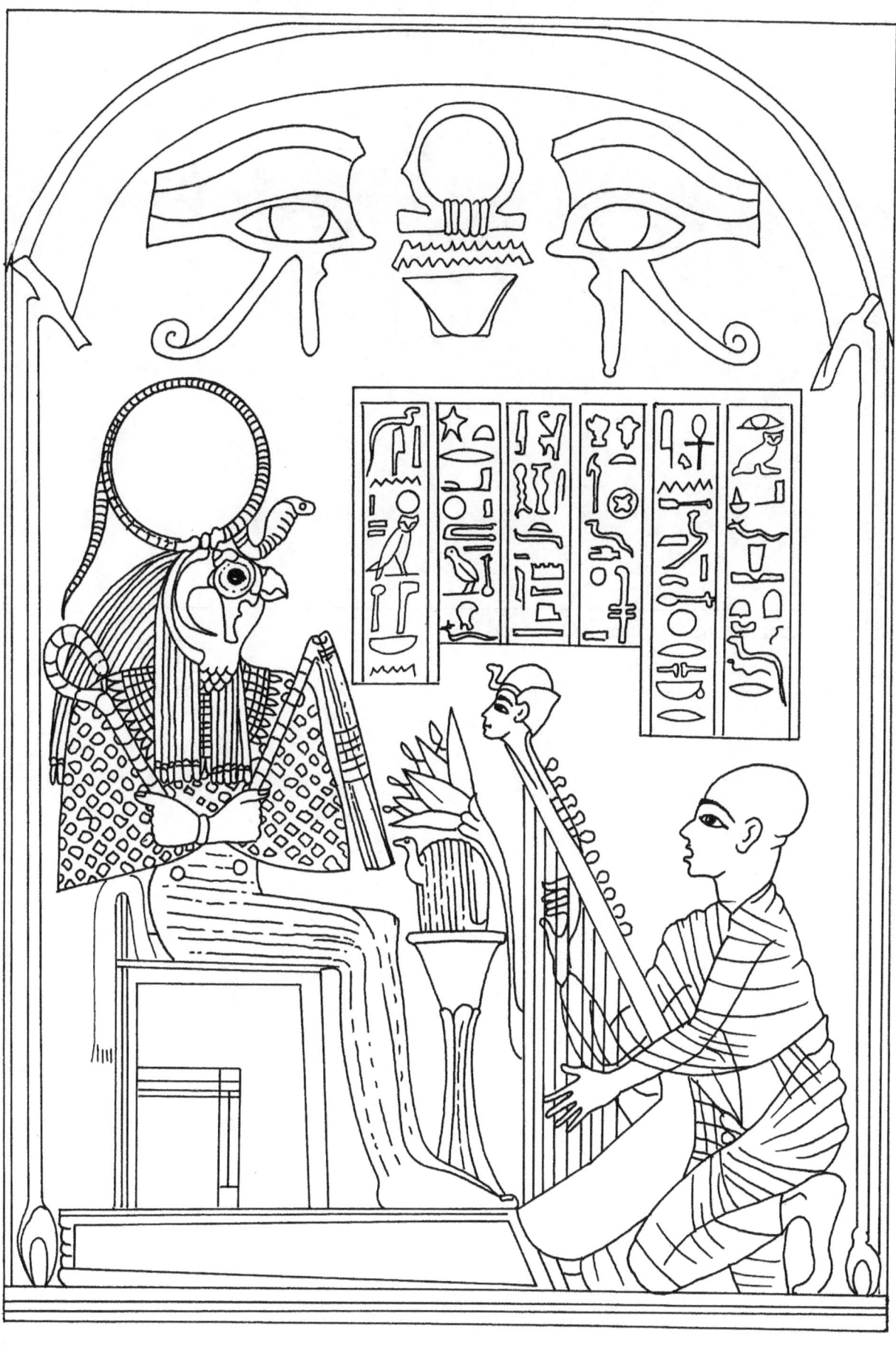

Supplicant leaving offerings to Osiris and Isis.

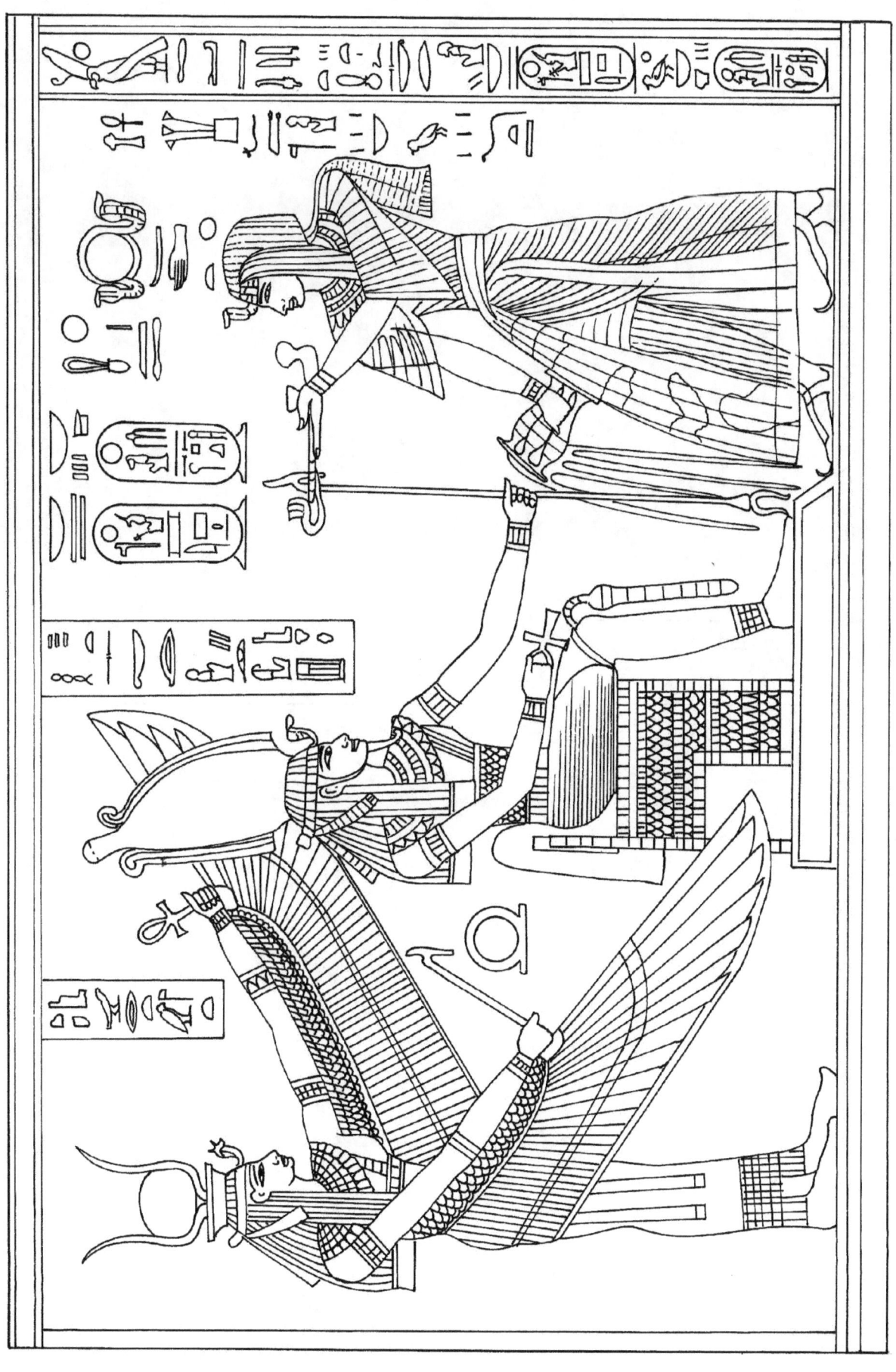

Ra, the sun God.

ANCIENT EGYPT 51

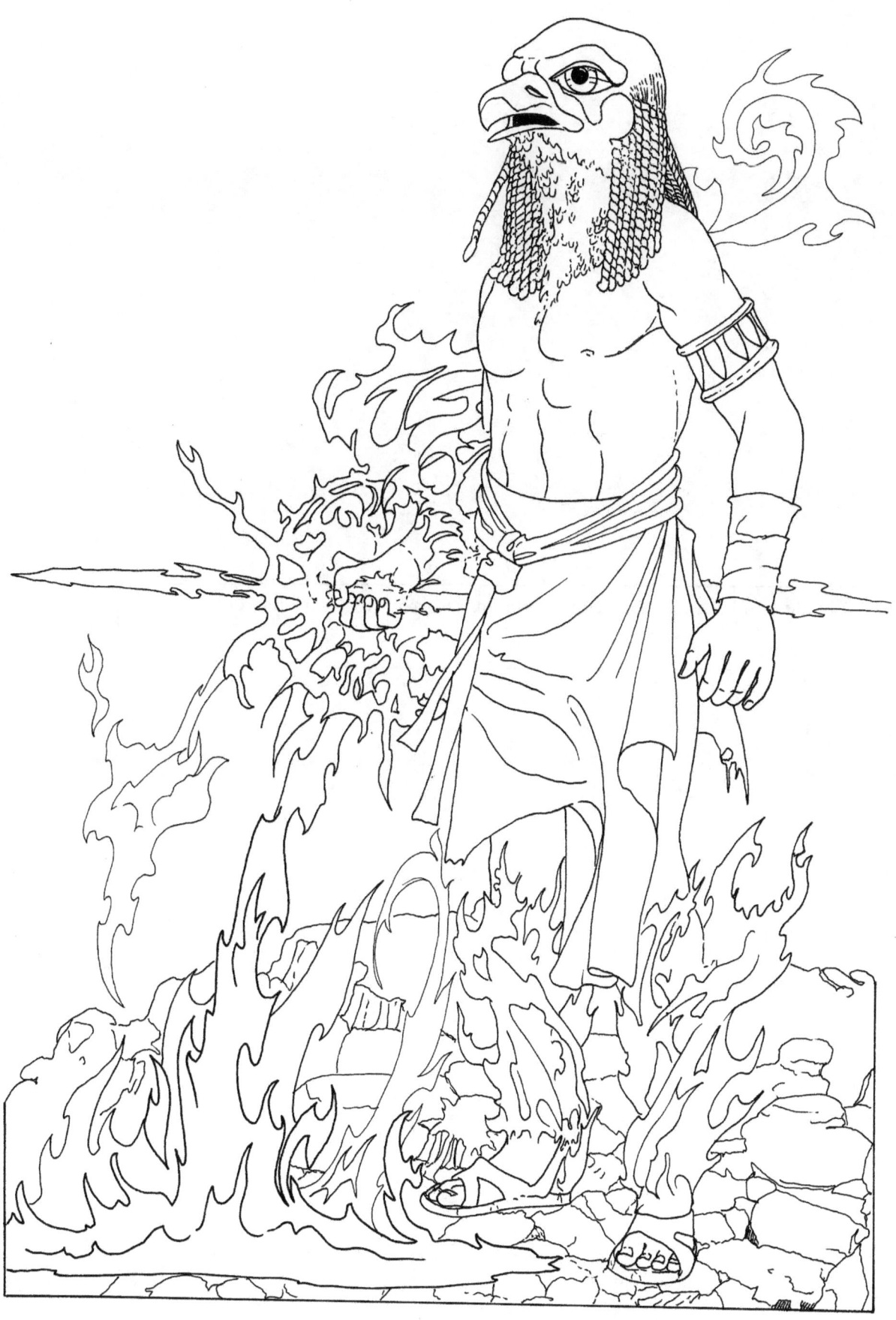

Isis, Goddess of health, marriage and wisdom, resurrecting her husband Osiris.

ANCIENT EGYPT

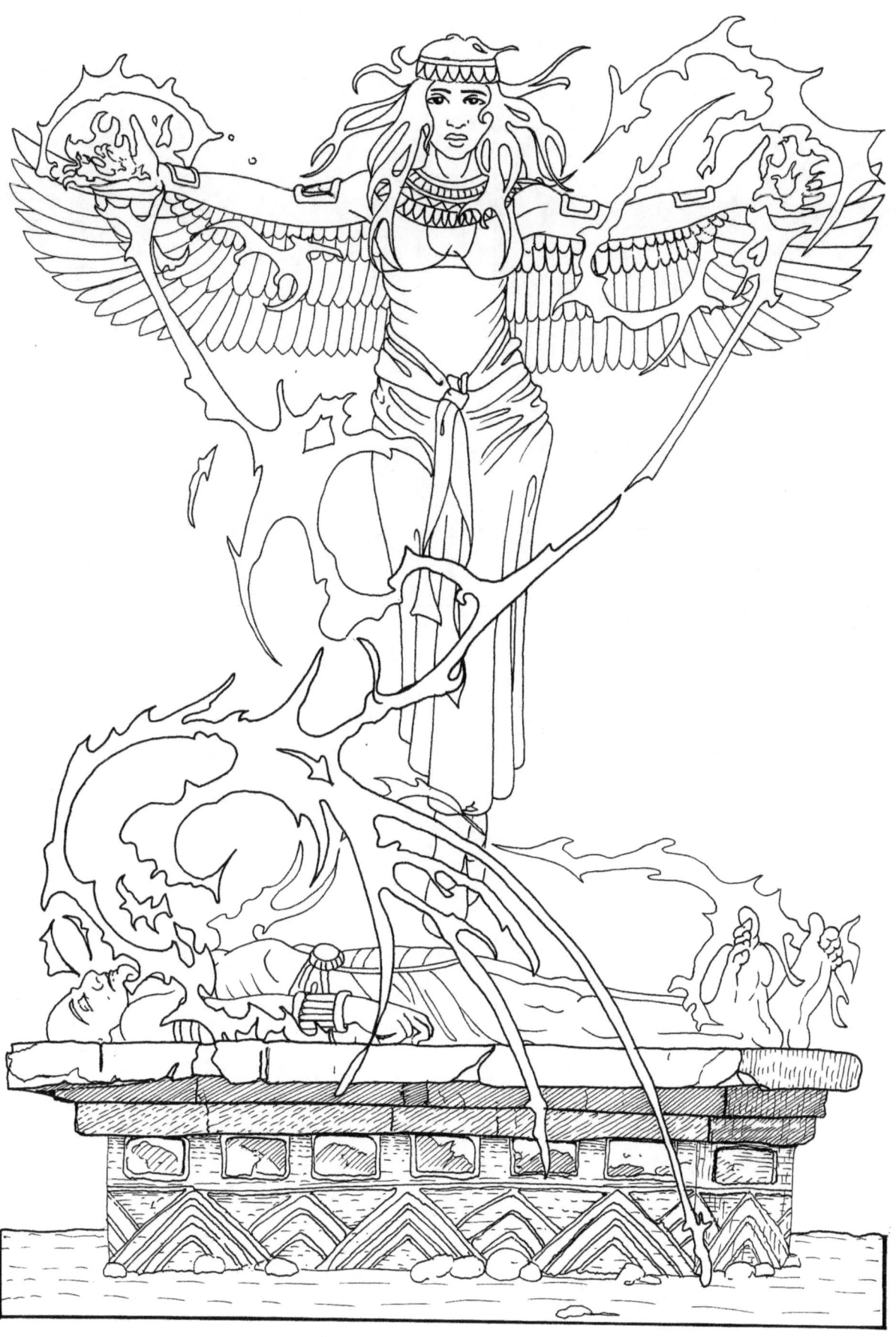

Horus, God of the sky and kingship.

ANCIENT EGYPT

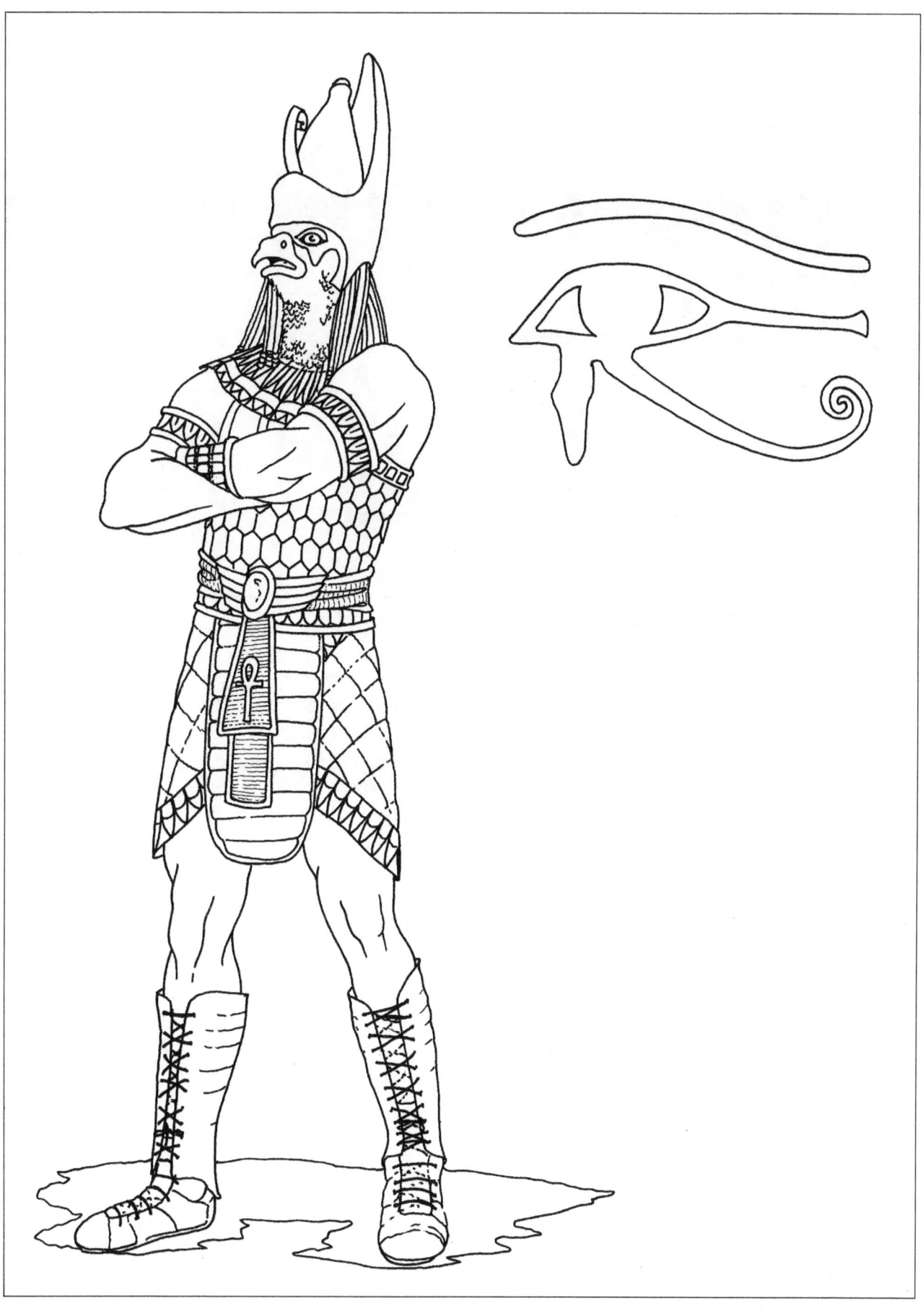

Set, God of chaos and storms.

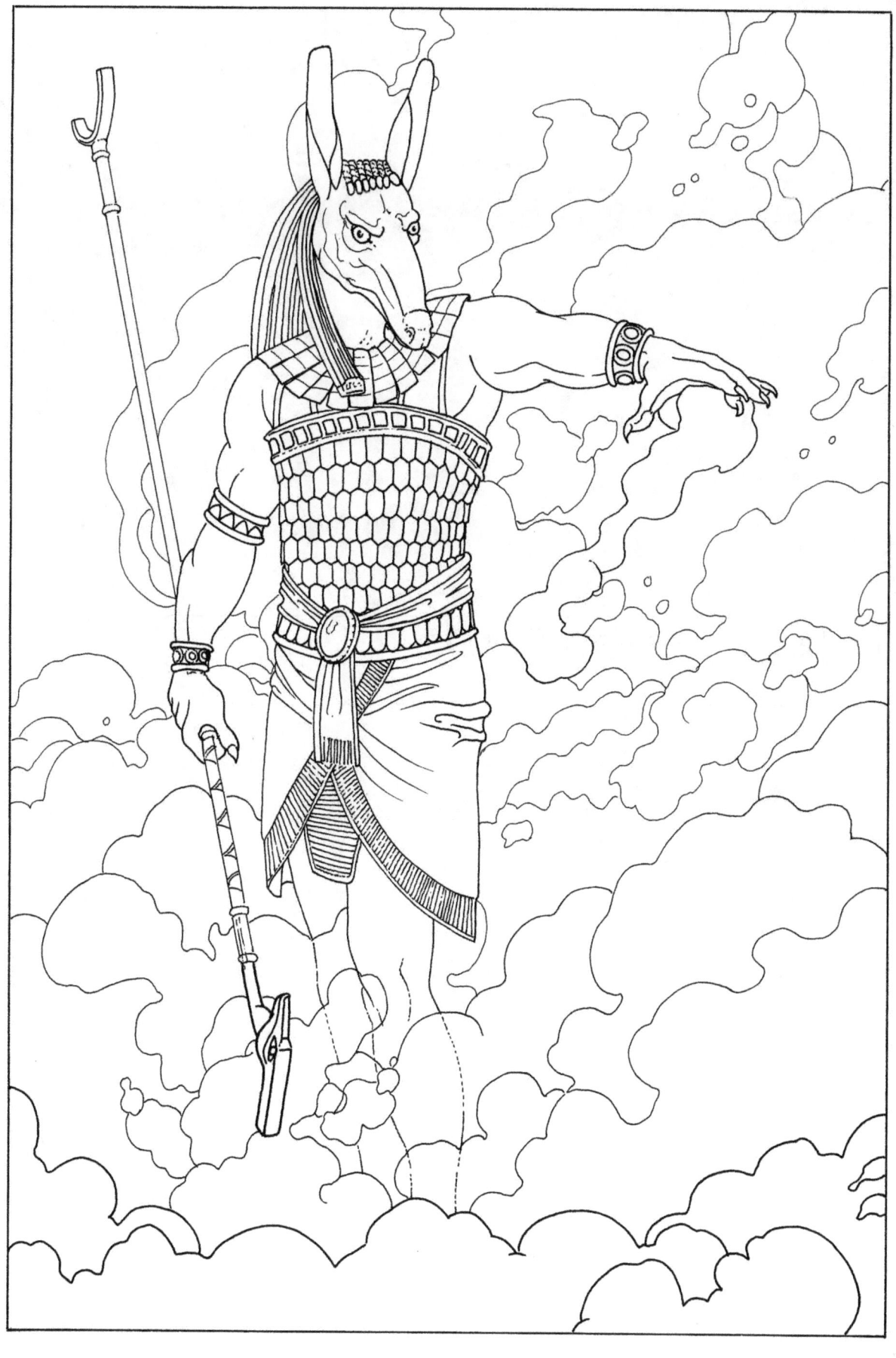

Wadiet, the cobra Goddess, deity of Lower Egypt.

ANCIENT EGYPT

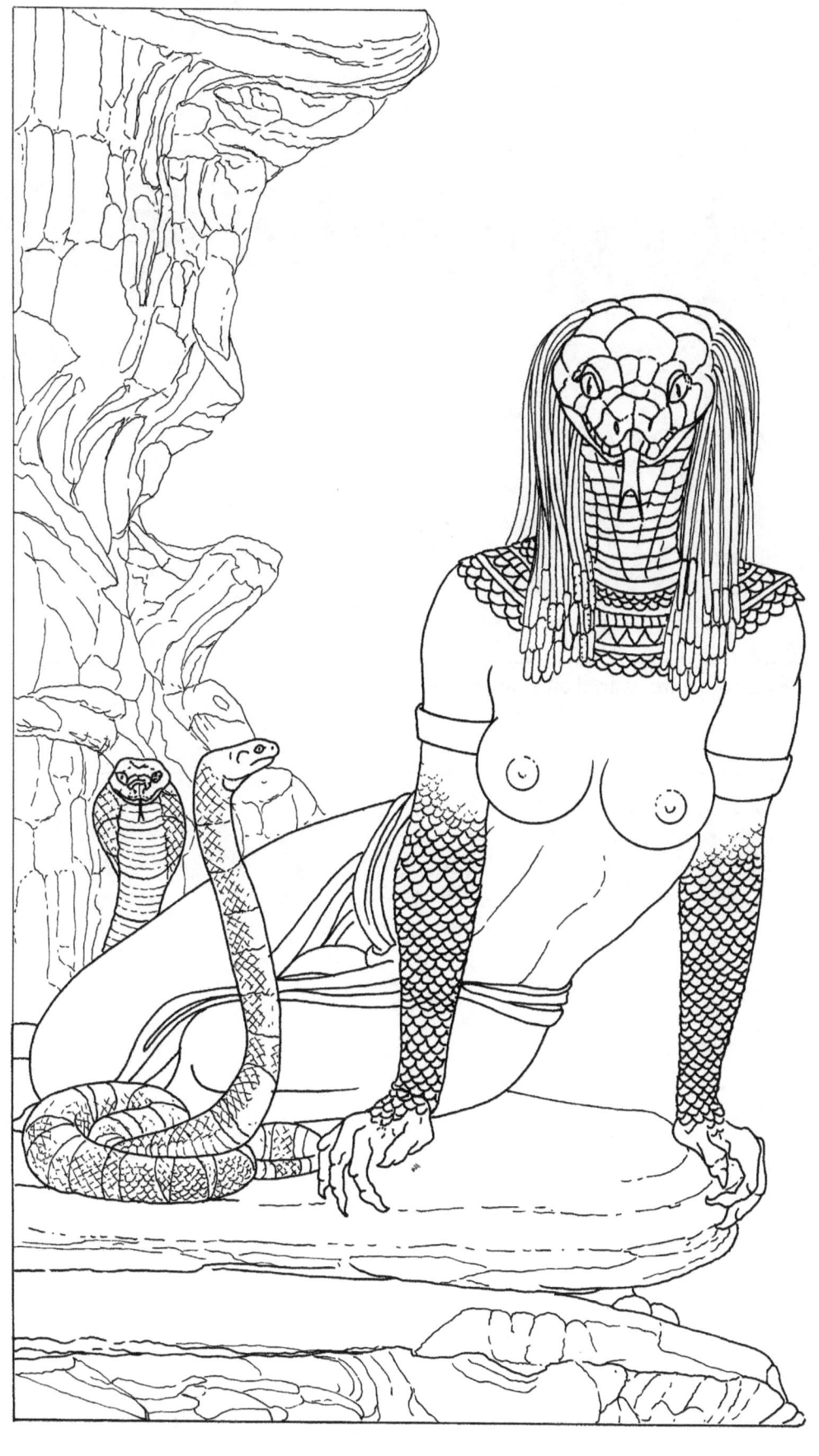

Sehmet, Goddess of fire, war, dance, love and medicine.

ANCIENT EGYPT

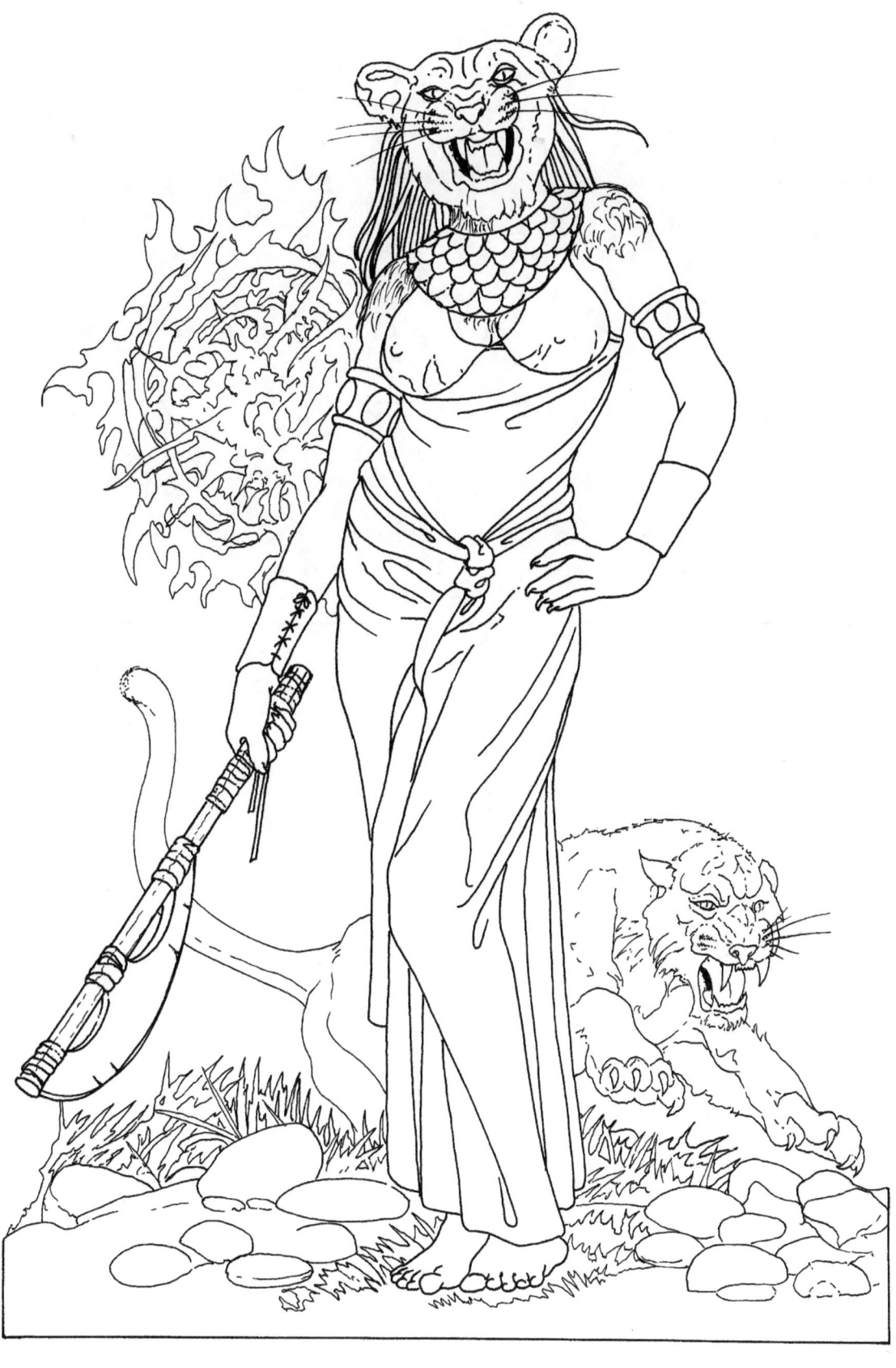

Ammit, the devourer of souls.

ANCIENT EGYPT

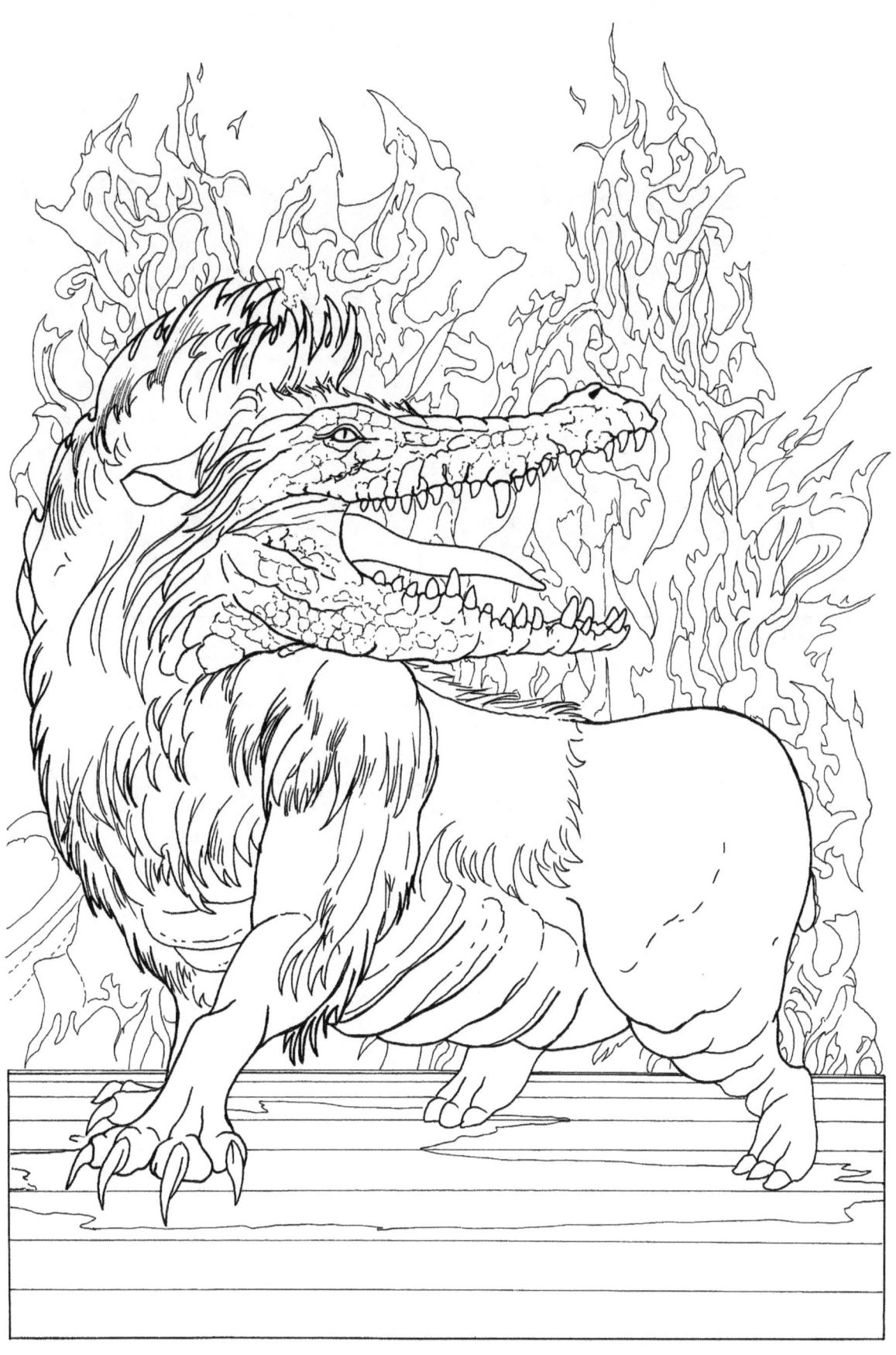

Maat, Thoth and Anubis.

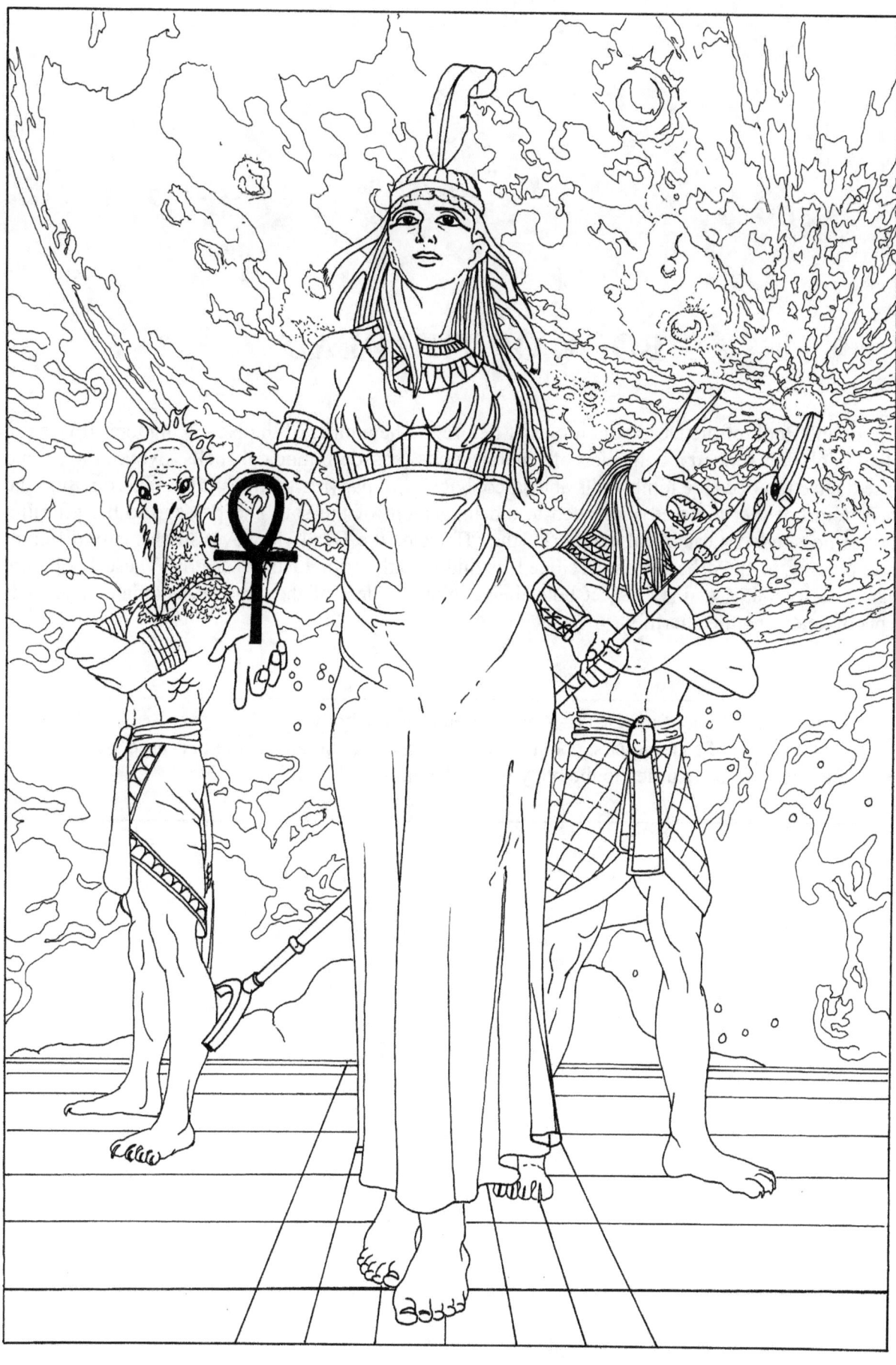

BOOK OF THE DEAD

The Egyptian "Book of the Dead" did not exist before the beginning of the New Kingdom. It was not an actual book, but formed a collection of funerary texts (based on magical spells, pyramid texts and coffin texts used to decorate tomb walls and sarcophagi, with papyrus sections often placed within the coffin or tomb of the deceased), intended to aid judgement of the soul and passage to the afterlife. There was no single or canonical version of the "Book of the Dead" however, with many different forms appearing to have been commissioned by individuals prior to their deaths. These books are invaluable to us today, as they reflect both the religious beliefs of the ancient Egyptians, and their concepts of death and the afterlife.

Above: The Book of the Dead – Anubis preparing the body.
Below: a set of canopic jars, containers for the internal organs of the deceased (so that they can be returned to the body when it comes back to life).

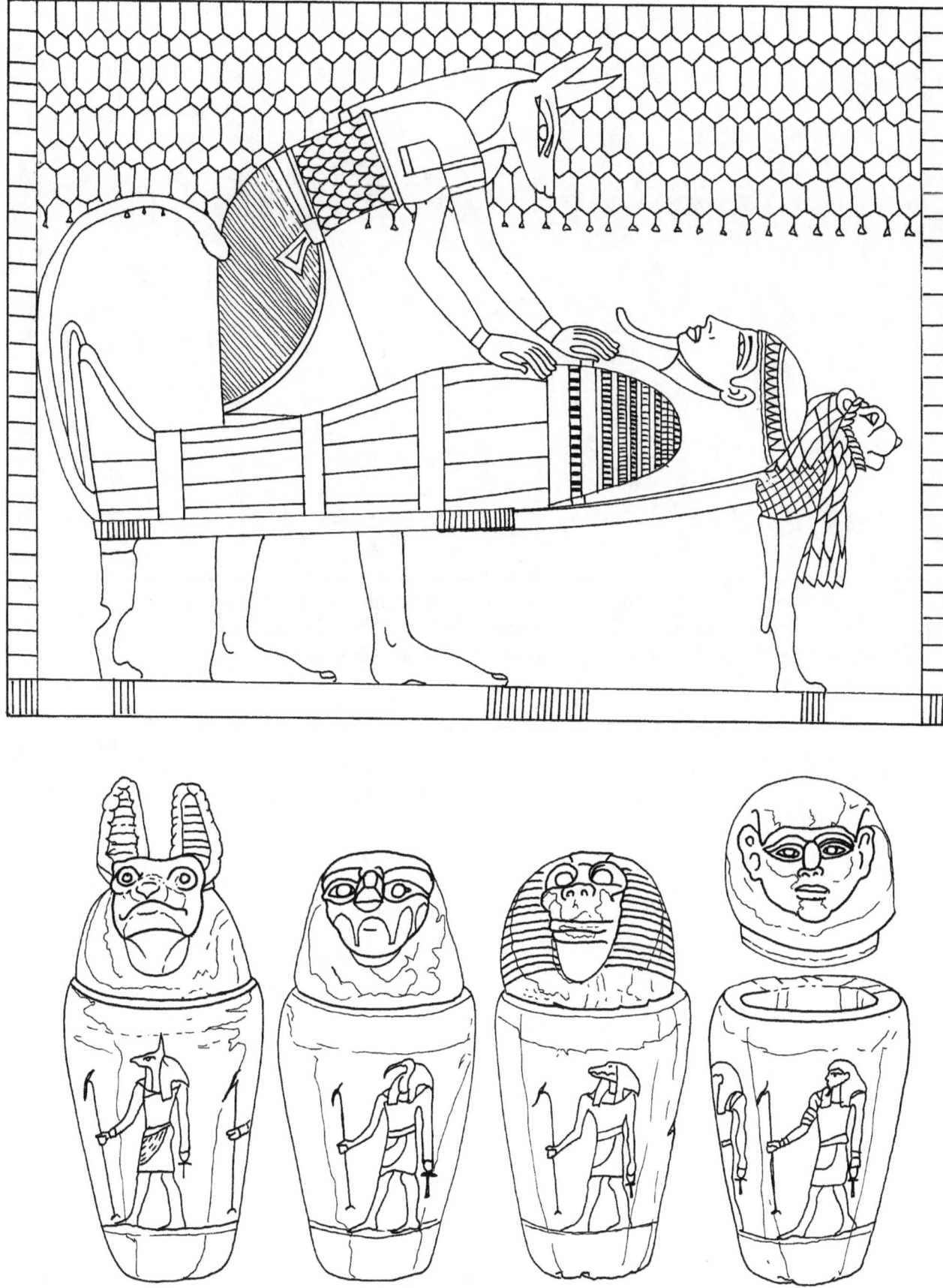

Hunefer's Book of the Dead: The deceased can be seen being judged by the god, Anubis (who weighs his heart against a feather from the head of the goddess Maat), recorded by the Ibis-headed god, Thoth and witnessed by the other Egyptian gods and goddesses.

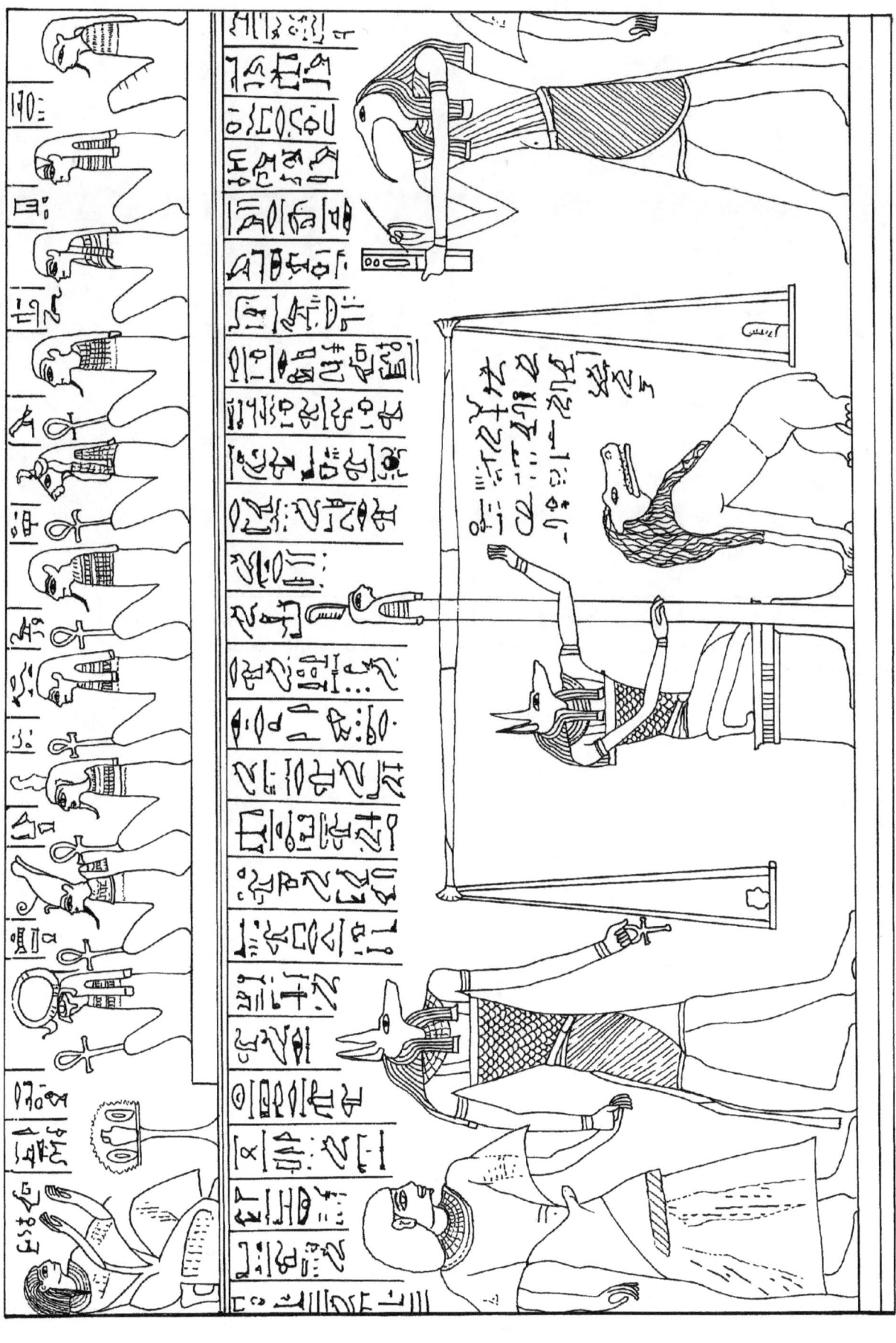

Hunefer's Book of the Dead: having passed the test of judgment, the falcon-headed god Horus presents the deceased to Osiris, who is flanked by the goddesses, Isis and Maat.

ANCIENT EGYPT

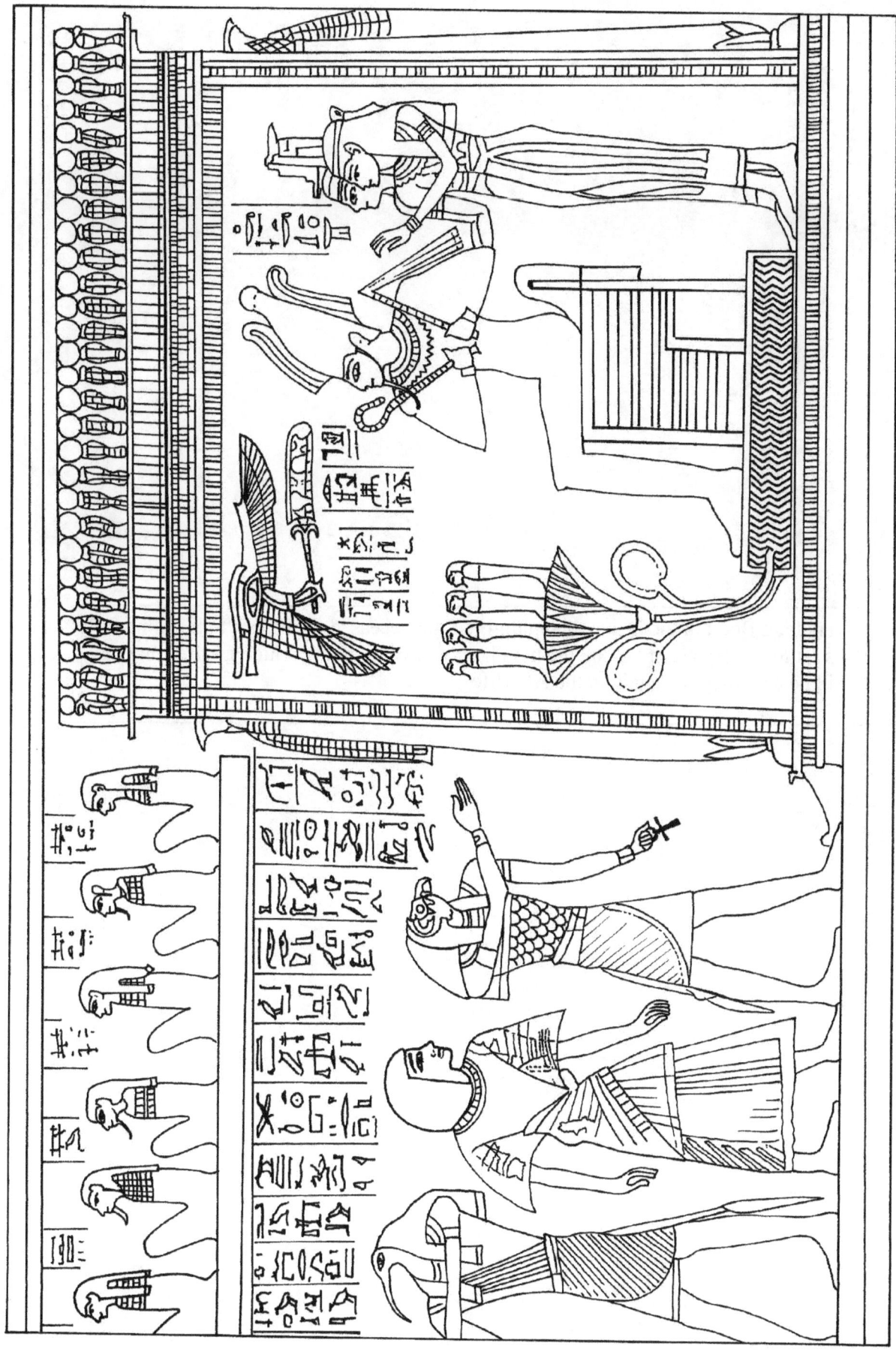

Hunefer's Book of the Dead: the mummy of the deceased is brought to his tomb by his family. They are attending the mouth opening ceremony, which ensures that he will be able to speak again in the Afterlife.

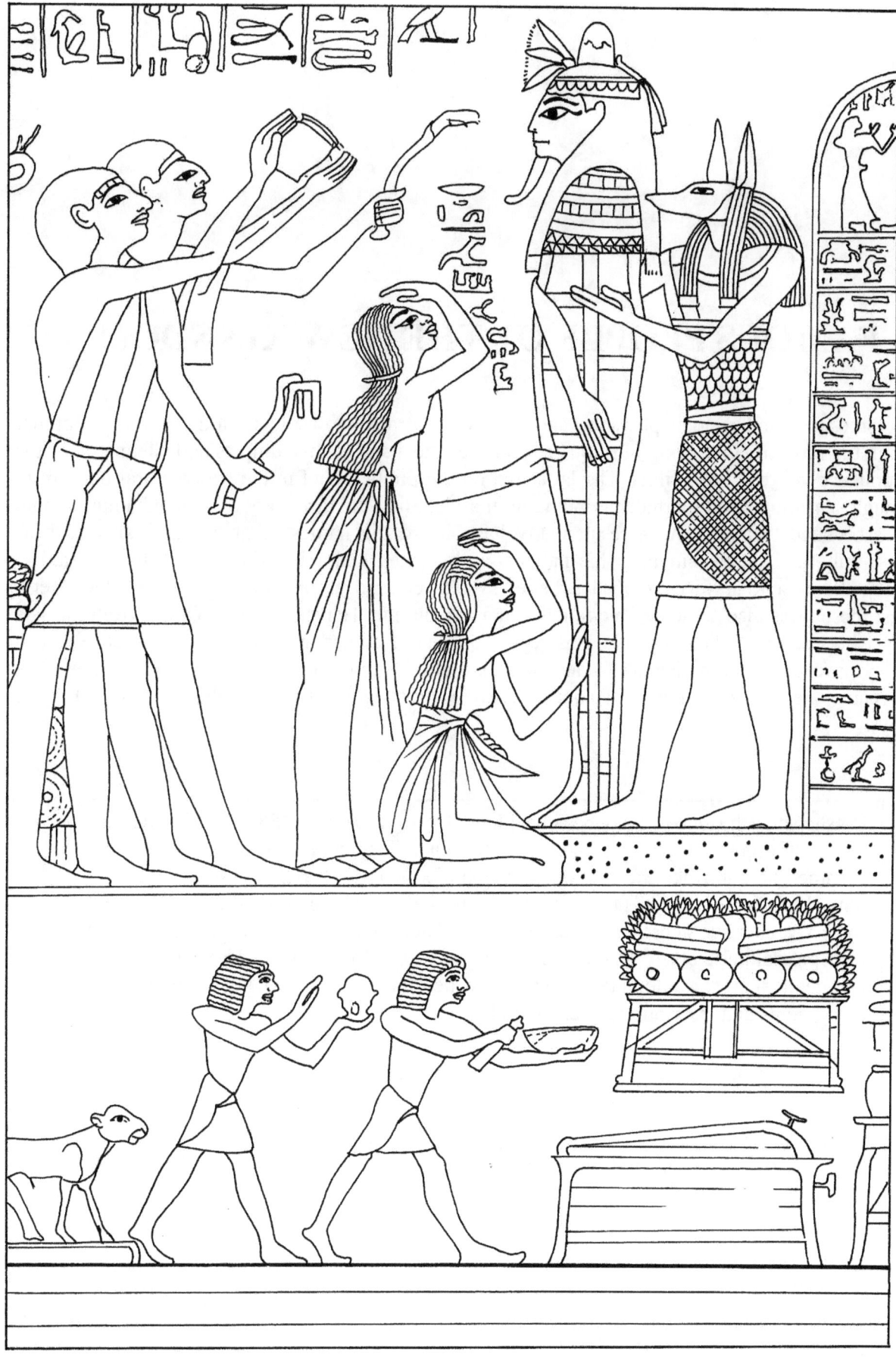

FAMOUS PEOPLE OF THE NEW KINGDOM

Many of the ancient Egyptian pharaohs and their queens are known to us today through popular culture, in the form of Hollywood blockbusters, such as the Ten Commandments and Cleopatra, or the more popular genre of horror films. The latter fed on the public belief in the supernatural brought to life through sensationalised journalism, including that detailing the discovery of Tutankhamun's tomb and its associated "curse". As a result many have heard the names of great Egyptians, such as Rameses, Imhotep, Tutankhamun, or his father, the deformed Pharaoh Akhenaten (who was said to have been the first to have developed a belief system centred around one living god, the Aten). Amongst these were also some notable female rulers, including, Hapshepsut (the Queen from the 18th Dynasty who became a Pharaoh, ruling as regent on behalf of her under-age son), Queen Nefertiti (who may have been the mother of Tutankhamun), and of course the beautiful, seductive Cleopatra (who became the mistress of two of ancient Rome's most iconic rulers, Julius Caesar and Mark Anthony).

> Hatshepsut (the queen who became pharaoh), c. 1508 to 1458 BC. Her name means "Foremost of Noble Ladies". Her father Thutmose I was a general but became Pharaoh when the previous Pharaoh died without leaving a son to succeed him. When her husband Thutmoses II died after a 15 year reign, she became regent for 3 years as her stepson and nephew (later Thutmoses III) was still a child. She then proclaimed herself Pharaoh, co-ruling with her for a further 15 years. After her death, her son attempted to eradicate her memory, destroying or defacing monuments and inscriptions referring to her.

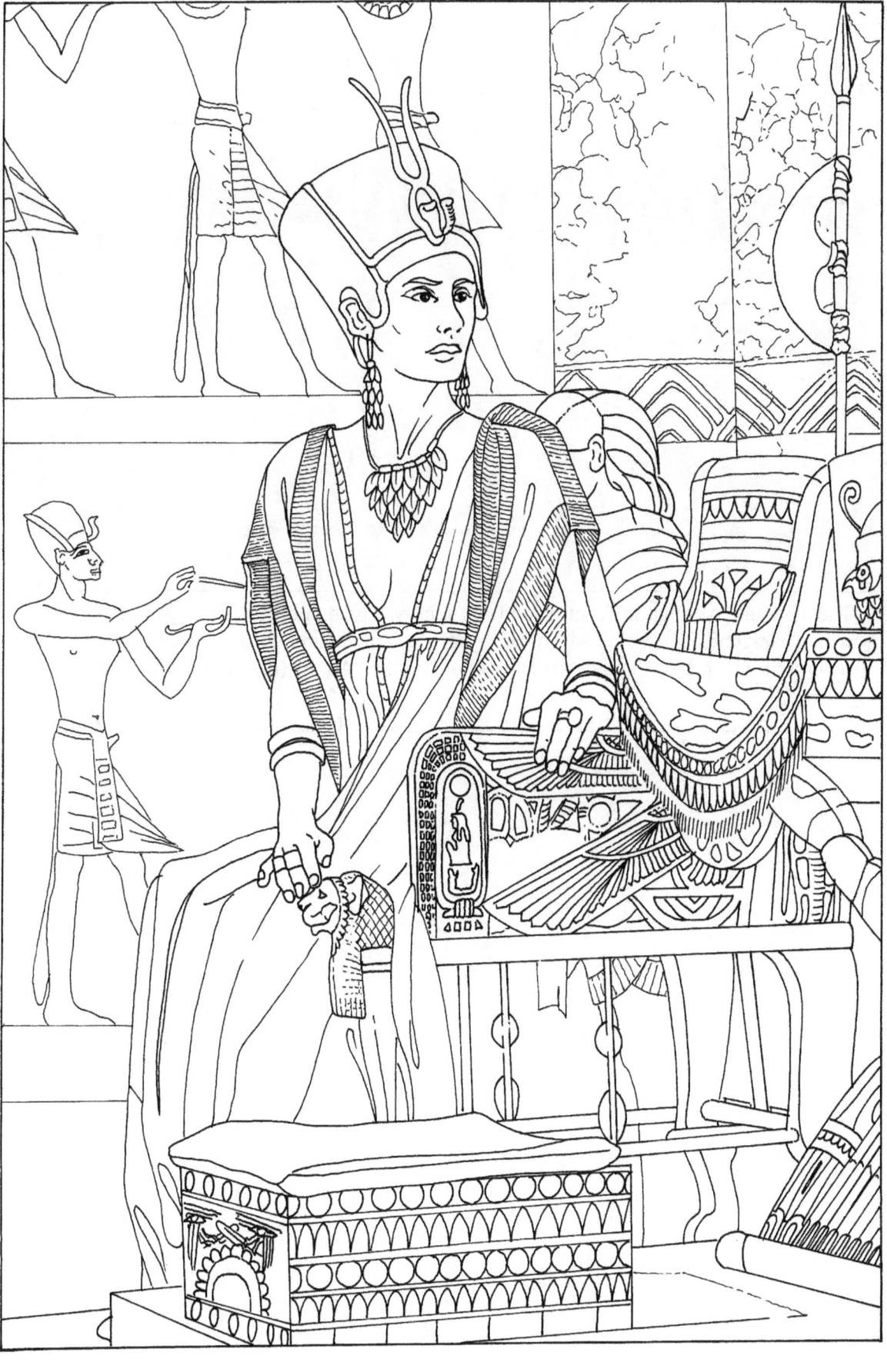

The Pharaoh Akhenaton (centre) and his family worshipping the one god Aten, with characteristic rays of sunshine to be seen emanating from the solar disk, several of which are terminated in hands holding the "Ankh" (the symbol of life).

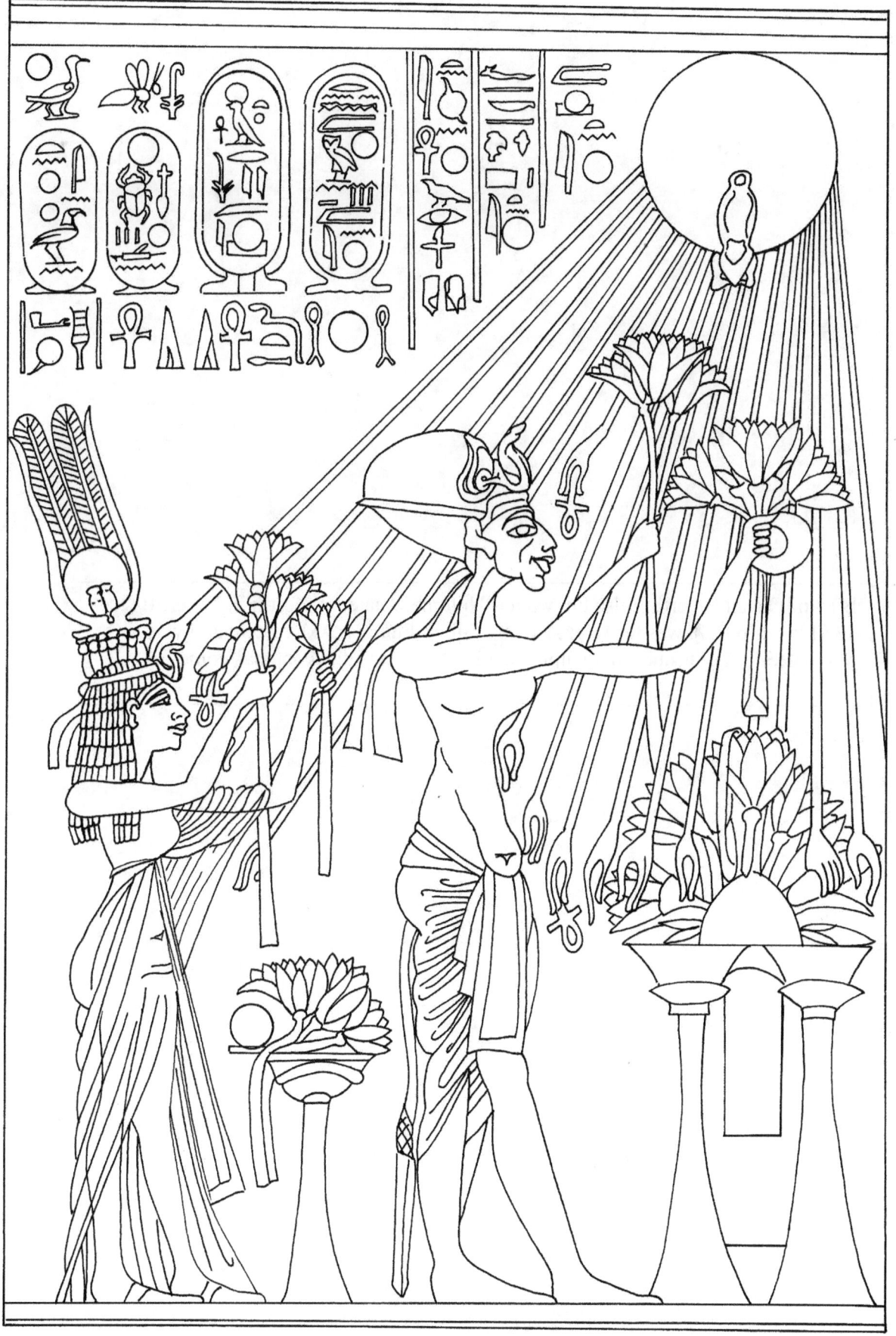

Bust of Queen Nefertiti (also known as "Neferneferuaten-Nefertiti"). Nefertiti (c. 1370 to 1336 BC), was the Great Royal Wife of Pharaoh Akhenaten, and was renowned for her beauty (her name meaning "The Beautiful one has come").

ANCIENT EGYPT

Pharaoh Tutankhamen's Death Mask. Tutankhamen was pharaoh in the 18th Dynasty, son of the heretic Pharaoh Akhenaten (who had established a new religion worshipping a Sun God, "Aten", centred at his new capital city of Amarna). After his father's death, he re-established the old Egyptian gods, moving the capital from Amarna to Luxor, and changing his name from "Tutankhaten" (which means "the Living image of Aten"), to "Tutankhamun".

Mystery surrounds the cause of his death at the age of only 18 years: suggestions being either a hunting accident or assassination, by poisoning or other unknown method of murder; with possible culprits including Ay, his chief vizir (who later divorced his wife; married the young pharaoh's widow; took over as Pharaoh; then remarried his first wife on the mysterious death of his new bride).

His tomb was considered "lost", until its discovery in 1922 by Howard Carter and Lord Carnarvon. Further speculation then arose over the "mysterious" deaths of the main members of the excavation, leading to stories of a "Mummy's Curse".

ANCIENT EGYPT

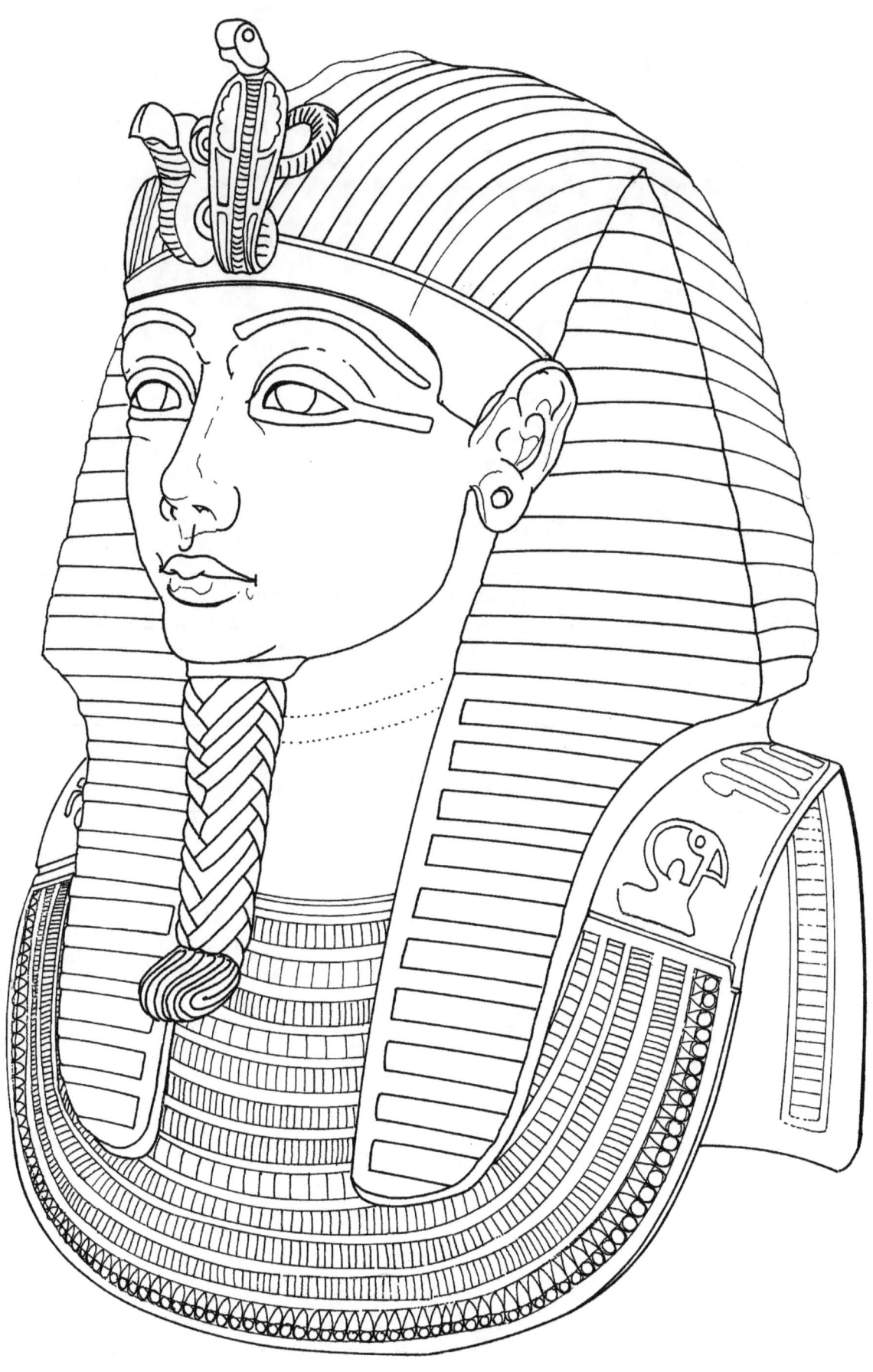

Ramses II (Rameses, or Ramesses), also known as "Ramesses the Great (c.1303 to 1213 BC, the third pharaoh of Egypt's 19th Dynasty). He is here depicted in his war chariot, dressed in a suit of scale armour, defeating the Hittites at the famous Battle of Qadesh (Kadesh).

Queen Cleopatra (Cleopatra VII Philopater), c. 69 to 30 BC, celebrated for her beauty and intelligence. She was the last ruler of the Ptolemaic Dynasty, becoming co-regent with her 10 year old brother, Ptolemy XIII on the death of her father, Ptolemy XII in 51 BC.

In 48 BC scandal arose when she became the lover of the Roman leader, Julius Caesar (providing him with a son, Caesarion), and later his friend, Mark Anthony (with whom she had a further three children). They then became embroiled in a dispute over Julius Caesar's succession with his nephew Octavian (later to take the name of "Augustus", as Rome's first Emperor), with Anthony's forces eventually defeated in a sea battle at Actium in 30 BC. Following this defeat, they fled back to Egypt, pursued by Octavian, where rather than facing further defeat and public humiliation, they chose to commit joint suicide on 12th August 30 BC.

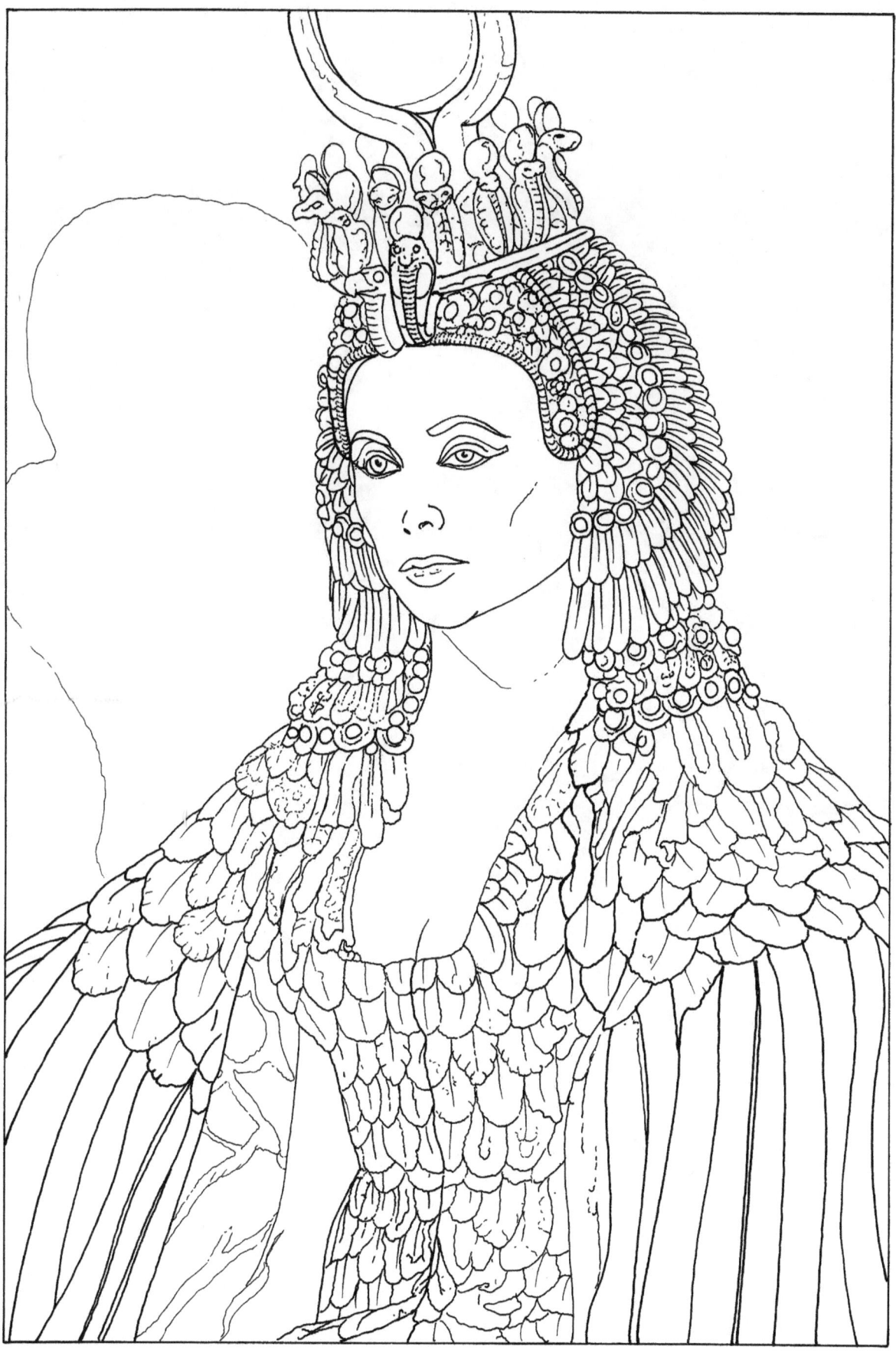

www.ingramcontent.com/pod-product-compliance
Lightning Source LLC
Chambersburg PA
CBHW080719190526
45169CB00006B/2433